ALSO BY SUSANA MARTINEZ-CONDE AND STEPHEN MACKNIK

Sleights of Mind: What the Neuroscience of Magic Reveals About Our Everyday Deceptions

CHAMPIONS OF ILLUSION

CHAMPIONS
OF ILLUSION

THE SCIENCE BEHIND
MIND-BOGGLING IMAGES AND
MYSTIFYING BRAIN PUZZLES

SUSANA MARTINEZ-CONDE
AND STEPHEN MACKNIK

SCIENTIFIC AMERICAN / FARRAR, STRAUS AND GIROUX

NEW YORK

Scientific American / Farrar, Straus and Giroux
18 West 18th Street, New York 10011

Library of Congress Cataloging-in-Publication Data
Names: Martinez-Conde, S. (Susana) | Macknik, Stephen L.
Title: Champions of illusion : the science behind mind-boggling images and mystifying brain
 puzzles / Susana Martinez-Conde and Stephen Macknik.
Description: First edition. | New York : Scientific American / Farrar, Straus
 and Giroux, 2017. | Includes bibliographical references.
Identifiers: LCCN 2017002594 | ISBN 9780374120405 (hardcover) | ISBN 9780374718398
 (ebook)
Subjects: LCSH: Optical illusions.
Classification: LCC QP495 .M37 2017 | DDC 612.8/4—dc23
LC record available at https://lccn.loc.gov/2017002594

Designed by Jonathan D. Lippincott

Our books may be purchased in bulk for promotional, educational,
or business use. Please contact your local bookseller or the Macmillan
Corporate and Premium Sales Department at 1-800-221-7945, extension
5442, or by e-mail at MacmillanSpecialMarkets@macmillan.com.

www.fsgbooks.com • books.scientificamerican.com
www.twitter.com/fsgbooks • www.facebook.com/fsgbooks

Scientific American is a registered trademark of Nature America, Inc.

1 3 5 7 9 10 8 6 4 2

Some of the content in this book has appeared previously in *Scientific American*
and *Scientific American Mind*, and on the authors' *Illusion Chasers* blog.

Frontispiece courtesy of Jorge Otero-Millan

TO THE THREE JOSEFINAS: NOVA, FELUCHA, AND CUQUITA

CONTENTS

CHAMPIONS
OF ILLUSION

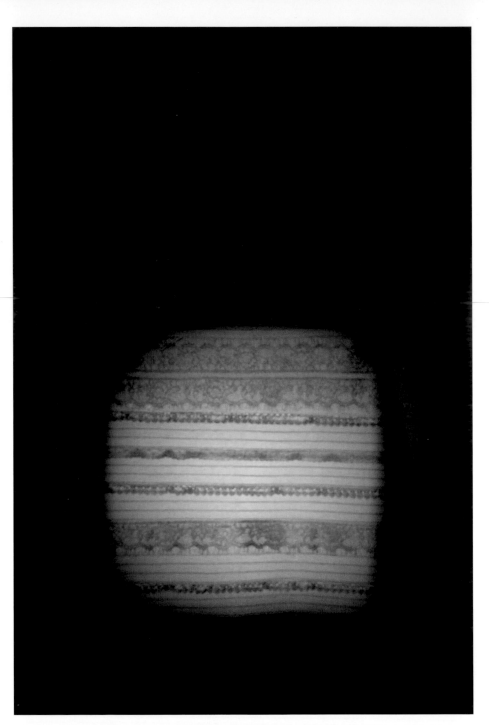

A re-creation of "The Dress" shows the effect of ambiguous illumination on the garment.

INTRODUCTION

o you remember experiencing that incredible Internet sensation "The Dress" for the first time? The two of us learned about the phenomenon when a science reporter sent us an e-mail asking for our comments. When we opened the image file attached to the reporter's e-mail, both of us saw a white-and-gold dress and were puzzled to learn that many people claimed to see the same dress in blue and black Huh? A quick Google search revealed that the mystery had a global scale: roughly half of humanity saw the dress as blue and black, and the other half as white and gold. A-list personalities like Taylor Swift and Kim Kardashian were arguing over it on Twitter! Our children told us that they saw blue and black on the same screen where we saw white and gold, while all of us viewed the dress at the same time. Incredible! It took weeks for the story to develop—and for some fast-moving research labs to do scientific testing—before we knew what had occurred. "The Dress" was a new class of perceptual effect, never before described. It is now considered to be the first illusion of color ambiguity, which causes different people—all with normal color vision—to see the same object as having completely different hues. As for what it means for the brain, the research is still ongoing. But one of the most important take-home messages presented by "The Dress" is that your perception is a very personal and subjective experience. There is nothing objective about it.

Your brain creates a simulation of the world that may or may not match the real thing. The "reality" you experience is the result of your exclusive interaction with that simulation. We define "illusions" as the phenomena in which your perception differs from physical reality in a way that is readily evident. You may see something that is not there, or fail to see something that is there, or see something in a way that does not reflect its physical properties.

Just as a painter creates the illusion of depth on a flat canvas, our brain creates the illusion

3

of depth based on information arriving from our essentially two-dimensional retinas. Illusions show us that depth, color, brightness, and shape are not absolute terms but are subjective, relative experiences created actively by our brain's circuits. This is true not only of visual experiences but of any and all sensory perceptions, and even of how we ponder our emotions, thoughts, and memories. Whether we are experiencing the feeling of "redness," the appearance of "square-ness," or emotions such as love and hate, these are the result of the activity of neurons in our brain.

Think of *The Matrix*, a movie about a future world in which humanity has lost the war against the machines. The robot victors keep humans subjugated by immersing them—without their knowledge—in a virtual reality simulation called the Matrix. In an iconic scene, Morpheus—one of the leaders of the human resistance—tries to recruit the reluctant hero Neo to the cause, but first needs to convince him that his whole life experience to date has been an illusion devised by their machine overlords. "What is real? How do you define 'real'?" asks Morpheus. "If you're talking about what you can feel, what you can smell, what you can taste and see, then 'real' is simply electrical signals interpreted by your brain." Morpheus then produces two pills—one red, one blue—and asks Neo to choose between them. The red pill will wake Neo up from the Matrix and release him into the real world. The blue pill will make Neo forget that he ever met Morpheus: he will remain in the Matrix, perpetually unaware that his complete experience is—and has always been—nothing more than a sophisticated dream. Neo takes the red pill, of course, and his adventures start. What the movie doesn't tell us is that even when Neo awakens from the fake world of the Matrix into the "real world," his brain continues to construct his subjective experience, as all our brains do. In other words, Neo remains stuck in the biological Matrix of his own mind.

Yes, there is a real world out there, and you perceive events that occur around you, however incorrectly or incompletely. But you have never actually lived in the real world, in the sense that your experience never matches physical reality perfectly. Your brain instead gathers pieces of data from your sensory systems—some of which are quite imprecise or, frankly, wrong. Accuracy is not the brain's forte, and so, like Neo, we all live inside our own heads, in an illusory Matrix.

(How can you know there is an actual reality out there? The short answer is that you can't. Not in any fundamental fashion. You could be dreaming, or you could be living as a disem-bodied brain in a vat, deluded into experiencing a computer simulation created by evil robots. However, for the purpose of advancing our discussion, we will make two fundamental assump-tions: 1. There is a reality outside of your brain. 2. You experience this reality through your sensory organs [retinal photoreceptors, taste buds, etc.], which are part and parcel of your neural machinery.)

Some people think illusions are simply mistakes made by the brain: erroneous computa-tions, failures of perception that we would do well to overcome. But what if illusions are good

things? Could it be that these peculiar mismatches between the inner and outer worlds are somehow desirable? Certainly, illusions are the product of evolution; we know that several illusions occur because of shortcuts that your brain takes to help you survive and thrive. Some of your misperceptions allow you to make lightning-fast assumptions that are technically wrong but helpful in practice. They can help you see the forest better—even if they make you discern the trees less precisely.

For example, you may underestimate or overestimate distances depending on various contextual cues. The psychologists Russell E. Jackson and Lawrence K. Cormack reported that when observers guessed the height of a cliff while looking down from the top, their estimates were 32 percent greater than when they were looking up from the cliff's base. This discrepancy appears related to the way we observe the same precipice from above versus below: a vertiginous cliff edge falling away from us versus a cliff face sloping into open land. Given that accidents are more likely to happen while climbing down rather than up, this height overestimation, when you look down from the top, may make you descend cliffs with greater care, reducing your chances of falling.

Illusions also offer a window into how our neural circuits create our subjective experience of the world. The simulated reality your brain creates—also known as your consciousness—becomes the universe in which you live. It is the only thing you have ever perceived. Your brain uses partial and flawed information to build this mind model and relies on quirky neural algorithms to alleviate those flaws.

Because illusions enable us to see objects and events that do not match physical reality, they are critically important to understanding the neural mechanisms of perception and cognition. They expose the structure that our mental universe is based on. To encourage the discovery and study of illusions, we created the annual Best Illusion of the Year Contest in 2005 to honor the best new illusions from the previous year and celebrate the inventiveness of illusion creators around the world: researchers, software engineers, mathematicians, magicians, graphic designers, sculptors, and painters fascinated with mapping the boundaries of human perception. The contest is playful, but for scientists it serves a deeper purpose. All the little perceptual hiccups that the contest showcases are opportunities to peer behind the neurological curtain and learn how the brain works. The contest has become an annual point of convergence for visual artists and scientists, and an event that illusion creators of all backgrounds look forward to, and prepare to compete in, every year. We have been particularly thrilled that the contest has spurred the creation and dissemination of new illusions that might otherwise remain undiscovered and unknown.

We are professors of ophthalmology, neurology, physiology, and pharmacology at the State University of New York (SUNY) Downstate Medical Center in Brooklyn, New York. Susana directs the Laboratory of Integrative Neuroscience, and Stephen directs the Laboratory

of Translational Neuroscience. Both of us trained in neuroscience as Ph.D. students, and we've worked together, studying the neural bases of illusions, since 1997. (It was not until 2002 that we started dating, and we got married only nine months afterward. Our friends still think that we were dating for years before we married, because we spent so much time together—just another illusion!)

When attending scientific conferences, we loved to check out the talk and poster sessions for the newest and coolest illusions. One need not be a Harvard-trained neuroscientist to enjoy the puzzlement and intellectual challenge posed by illusions, but they are particularly irresistible to perceptual researchers, because they provide us with a great handle on the problem of what, exactly, our brains are doing when we experience anything. If illusions, by definition, dissociate reality from objective perception, then to understand conscious experience we must locate the neurons, circuits, and brain areas that activate in such a way as to match our perception of the illusion rather than reality itself—no matter how large the discrepancy might be.

Early in our careers, we volunteered to host the twenty-eighth gathering of the European Conference on Visual Perception (ECVP), the premier transnational conference for visual researchers. We were longtime fans of the ECVP and, encouraged by the conference cofounder Lothar Spillmann, we proposed to hold the annual meeting in Susana's hometown of A Coruña, Spain.

We were terrified and exhilarated in equal measure—terrified that we'd screw it up and exhilarated that we might not—when our offer to host was accepted. Around that time, we became faculty members at the Barrow Neurological Institute in Phoenix, Arizona—which meant that we now had to plan a conference with more than eight hundred attendees from over five thousand miles away!

Despite this challenge, we wanted to do something new—something more—with the opportunity we had been given to organize this important conference. Our goal was to make the meeting special for academics as well as the general public. Illusions, we realized, were the answer: we resolved to hold the world's first contest in which scientists, artists, software designers, mathematicians, and creative people from any field could submit new illusions that they had created or discovered. They would all compete for the title of Best Illusion of the Year.

That's how we hosted the first edition of the Best Illusion of the Year Contest as part of the 2005 ECVP conference. We came up with a simple set of rules. Illusions competing in the contest would need to be novel—previously unpublished, or published no earlier than the previous year. Then an international panel of illusion experts—artists, scientists, and science educators—would select ten illusions that were the most innovative, counterintuitive, spectacular, beautiful, and significant to the understanding of the human mind. Finally, the top ten illusion creators would present their awe-inspiring brain twisters at an awards gala, and the audience would vote for first-, second-, and third-place winners. It was the Oscars of illusion.

The contest was a huge success. Because the organizers of the ECVP change every year, we had imagined that the contest would be a one-time event, but everybody, it seemed, loved the competition and wanted more. Both our colleagues and the public asked for future editions of the Best Illusion of the Year Contest.

We were intrigued by the possibility but also a little wary. Could we have an illusion contest every year? We received more than seventy illusion submissions in the first year, but perhaps some of these were illusions that had been sitting in people's drawers for years, if not decades. Could illusion creators around the world keep up with the demand of a yearly contest? Or would the quantity, and especially the quality, of the illusions decline after the first few years? We decided to give it a shot.

The practicalities of organizing what would become an annual contest required that we hold it in the same place every year—ideally, on the same continent as where we lived. So we set out to hold future contests in Florida, coinciding with the annual gathering of the Vision Sciences Society. We also created the Neural Correlate Society, a nonprofit organization that brings together researchers from fields as diverse as art, mathematics, psychology, and neuroscience to promote scientific understanding of perception and cognition, and that runs the contest today.

We were delighted to discover that our initial concern—that the illusion well would run dry—was wrong. Amazing illusions kept coming in, and we learned that many illusion creators around the globe marked the dates of the contest in their calendars and set out to invent new illusions specifically for our annual event. Because of its very existence, the contest actually spurred the creation of new and better illusions! By the fifth or sixth year of the contest, we realized that, as long as people remained captivated by the workings of the human mind, they would keep on inventing ways of challenging their perceptions and the perceptions of others. More than ten years on, the illusions are as strong as ever.

The Best Illusion of the Year Contest also allows us to see art and science merge in beautiful ways. Previously, scientists tended to create illusions from simple lines and geometrical shapes, and artists focused on eye-popping illusions without much thought of state-of-the-art neuroscience. But today, science and art overlap more than ever. Scientists increasingly use graphic-design tools to enhance the aesthetics of their illusions, and artists have grown more knowledgeable about the neuroscience behind the magic.

In 2014, after living in Phoenix for ten years, we accepted professorships in New York, and moved to the city with our three children. Around the same period, we felt that it was time to revamp the contest—which had just celebrated its tenth anniversary—and take it to the next level.

Holding a live event during which creators presented their illusions in front of one thousand spectators was a lot of fun. Over the years, a number of magicians, musicians, and other entertainers have emceed the event or performed during the vote counting. The renowned

magician and skeptic James Randi—aka the Amaz!ng Randi—performed in two contests, and the Las Vegas headliner and champion of comedy magic Mac King emceed an unforgettable tenth-anniversary gala.

Still, the contest's main audience was always the millions of Internet users who follow the competition, invent new versions of the illusions, and make the most mind-warping entries go viral.

If we moved the contest completely online, we reasoned, anybody in the world with an Internet connection could submit illusions and vote for the winners—not just people with the time or means to travel to Florida for the event. We knew we previously had lost international contestants who had stunning illusions for these reasons.

Whereas the top ten contestants used to have five minutes each to present their illusions to a live audience—who then voted using paper ballots—having an online contest meant reducing the time allotted per illusion. We could no longer expect voters to view illusions for fifty minutes (an eternity, by Internet standards!) before choosing their favorite.

So, in 2015, we asked contestants to send one-minute videos to compete online for the first time. An international judging panel still pared down submissions to the top ten, but anybody in the world with Internet access could vote. The contest was no longer limited to a specific audience.

It was a great move. The illusions in 2015 were terrific, and the savings from moving the contest online allowed us to offer cash prizes to the winners.

We hope that you will help select the next Best Illusion of the Year—and especially that you submit your illusion creations to the contest! Anybody can compete, and the instructions are posted online. In the meantime, this book showcases some of our favorite illusions from the contest's first decade, and offers you a chance to glimpse the world of misperception, where neuroscience, art, and magic converge. We'll also tell you a bit about how the illusions were created and what they reveal about the way our brains operate in everyday life. The mind tricks you are about to experience will provide you with an increased awareness of the subjective quality of your private reality, and insider knowledge that these apparent neural failures—illusions—are critical to how we perceive the world.

Each chapter is dedicated to a specific type of illusion, such as color, shape, size, and so on. Most of the illusions featured here come from the contest, but we have also incorporated a few additional illusions to help explain important ideas. At the end of the book, you'll find a special section devoted to dynamic illusions that are best viewed on the screen. Be sure to go online and check these out if you wish to delve deeper into the limits and wonders of your perception. We've also included more information about the people behind these illusions. We hope you enjoy the show!

BRIGHTNESS AND
CONTRAST ILLUSIONS

Nothing is more fundamental to our vision than how we see the brightness of an object. But even so, our visual system plays fast and loose with reality and serves up—for your viewing pleasure—monstrously bizarre and perplexingly inaccurate interpretations of the physical world. And this raises the question that constantly cycles through the brains of vision scientists: Why doesn't human vision faithfully represent the world we see? The answer, as any student of Darwin should agree, is that illusions must help us survive (or at the very least not hinder our survival). If illusions were harmful, it is likely that they would have been weeded out of the gene pool by now. Mutations that work against survival—and reproductive success—are self-limiting.

But how can a visual illusion be useful? To illustrate, we'll do an experiment. Go to a dark room in your domicile with a cell phone and a book (an actual book, made of paper). Then dimly illuminate the pages of your book, using your phone, just enough to see the letters. White pages, black text—looks like a book, right? After you have completed this part of the experiment, head outside on a sunny day with the same book. Under direct sunlight, look at the same page; it looks identical, right? If you think it through, that's impossible, because the physical reality under the two lighting conditions is very different! When you read black text on a page lit by a dim cell phone, the amount of light reflected by the white paper is around 100,000 times lower than the amount of light reflected by the black letters in direct sunlight. So why don't the black letters seem super-white (100,000 times brighter than white) outside? The reason is that your brain doesn't care about light levels; it cares about the contrast between the lightness of objects. It interprets the letters as black because they are darker than the rest of the page, no matter the lighting conditions.

The illusion that allows us to identify an object as being the same under different lighting conditions is a very useful one. It helps us survive. For one thing, it might have allowed our ancestors to recognize their children inside and outside the cave . . . and therefore not eat them!

THE
WORLD'S LARGEST
BRIGHTNESS ILLUSION

BY BARTON ANDERSON AND JONATHAN WINAWER

**UNIVERSITY OF SOUTH WALES, AUSTRALIA,
AND MASSACHUSETTS INSTITUTE OF TECHNOLOGY, U.S.A.**

2005 FINALIST

ur brain does not perceive the true brightness of an object in the world (for instance, measured with a photometer), but instead compares it with that of other nearby objects. For instance, the same gray square will look lighter when surrounded by black than when it is surrounded by white. This illusion by Anderson and Winawer extends this concept dramatically. In the images, the four sets of chess pieces are identical. The backgrounds are the only things that change: the images on the two bottom rows show the same chess pieces as the images on the top two rows, only with the backgrounds removed. We perceive the first-row pieces as white and the second-row pieces as black because of the variations in the clouds engulfing them. Checkmate!

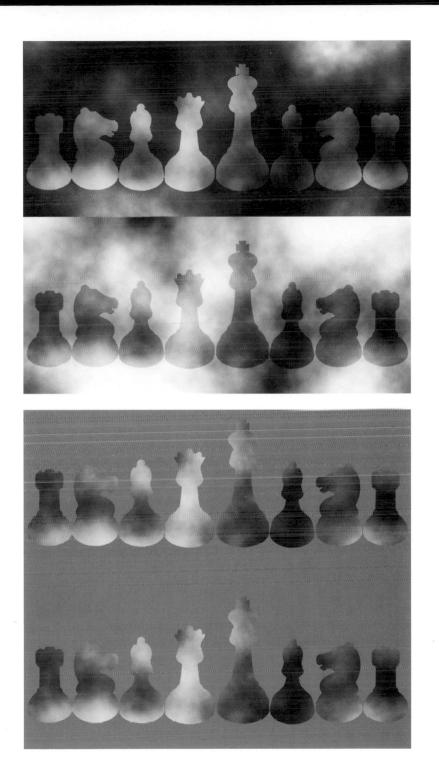

HERE COMES THE SUN

BY ALAN STUBBS

UNIVERSITY OF MAINE, U.S.A.

2006 FINALIST

old this book at a comfortable distance from your eyes while looking at the picture. Then bring the book gradually closer. As the image approaches, you should notice that its brightness seems to increase. Move the book back and forth to make the brightness increase and decrease repeatedly. The neural bases of this effect are not yet understood, but the explanation may reside in how our visual system reacts to expanding versus contracting objects as a function of their distance from the observer. Some motion-sensitive neurons of the visual pathway become selectively activated when visual objects either loom (expand) or recede (contract). It could be that the ghostly, transparent white cloud radiating from the center of the image appears less salient to those neurons than the highly visible red-blue background. If so, when the cloud and the background expand and contract together, your neurons may signal a difference in the relative amounts of expansion and contraction—so that one element appears to loom or recede more than the other, even though no difference actually exists.

THE PRIMAL FLASHLIGHT

BY LOTHAR SPILLMANN, JOE HARDY, PETER DELAHUNT, BAINGIO PINNA, AND JOHN WERNER

UC DAVIS MEDICAL CENTER, U.S.A.; UNIVERSITY OF FREIBURG, GERMANY; POSIT SCIENCE, U.S.A.; UNIVERSITY OF SASSARI, ITALY

2009 FINALIST

All you will need to experience this illusion is a cardboard tube, such as a paper-towel roll or a poster tube. Look through the tube with one eye, and keep the other eye open. Point the tube at a bright wall. After just a few seconds, the circle you see through the tube will look much brighter than the rest of the wall! If you look at a textured surface, the illusion will enhance not only the brightness and color but also the details in the pattern. Vision scientists do not fully understand this phenomenon, but it could be that the dark inner cardboard walls enhance the brightness of the scene trapped inside the tube, compared with the rest of the visual field. Another nonexclusive possibility is that looking through the tube helps focus your attention in one eye more than in the other.

WEAVES AND
THE HERMANN GRID

BY KAI HAMBURGER AND ARTHUR G. SHAPIRO

UNIVERSITY OF GIESSEN, GERMANY, AND BUCKNELL UNIVERSITY, U.S.A.

2007 FINALIST

The Hermann Grid Illusion, reported by the German physiologist Ludimar Hermann in 1870, consists of a white grid on a black background or a black grid on a white background. Faint, ghostly spots appear at the grid's crossings, even though there is nothing there. The classical explanation for this illusion is based on experiments carried out by the neurophysiologist Günter Baumgartner in 1960. Baumgartner proposed that neighboring neurons of the early visual system—the first areas of the brain to respond to visual information—enhance the perceptual contrast at the grid's crossings by suppressing each other's activity. This process—known as lateral inhibition—was first described in neurons in the horseshoe crab's eye, a discovery that led to Keffer Hartline's 1967 Nobel Prize. Hamburger and Shapiro's novel variant of the Hermann Grid Illusion interlaces light gray vertical columns with dark gray horizontal rows (or the other way around, however you prefer to think about it). As the lightness of the background varies from black to white, the apparent brightness of the illusory spots at the crossings reverses.

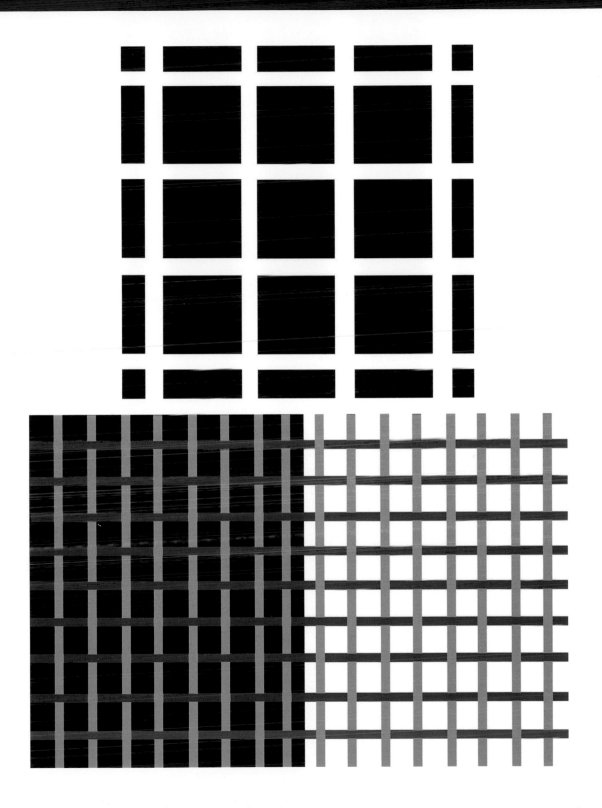

BRIGHT PATCHES

BY ROB VAN LIER AND MARK VERGEER

RADBOUD UNIVERSITY, NIJMEGEN, THE NETHERLANDS

2006 FINALIST

his perceptual effect is another novel variation of the classic Hermann Grid Illusion. The "patches" at the intersections of the grid above look brighter than the rest of the grid. And yet the entire grid is in a single tone of gray.

THE ILLUSION OF SEX

BY RICHARD RUSSELL

HARVARD UNIVERSITY, U.S.A.

2009 THIRD PRIZE

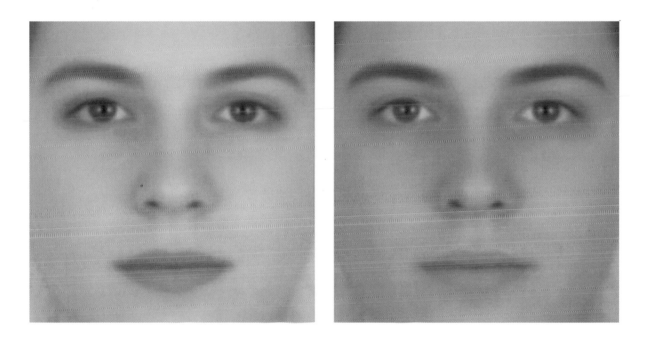

You may perceive these two side-by-side faces as female (left) and male (right). But both are versions of the same androgynous face. The two images are identical, except that the contrast between the eyes and mouth and the rest of the face is higher for the one on the left than for the one on the right. This illusion shows that contrast is an important cue for determining gender: low-contrast faces appear male, and high-contrast faces appear female. It may also help explain why females in many cultures darken their eyes and mouths with cosmetics: a made-up face looks more feminine than a face without makeup.

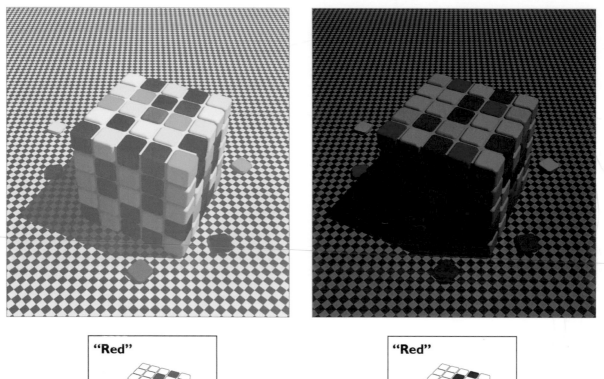

"Red"

"Red"

Constancy

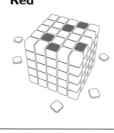

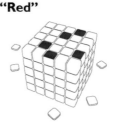

"Blue"

"Yellow"

Contrast

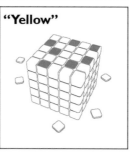

COLOR ILLUSIONS

Take a look at the red chips on the top two Rubik's cubes on the opposite page. They are actually orange on the left and purple on the right, if you look at them in isolation. They only appear more or less equally red across the images because your brain is interpreting them as red chips lit by either yellow or blue light. This kind of misperception is an example of "color constancy," the mechanism that allows you to recognize an object as being the same in different environments, and under very diverse lighting conditions.

Color constancy is a remarkable skill, because an object's surface can be colored only by virtue of the photons it reflects from a light source. That is, every object is tinted by both the color of its surface (defined as its ability to reflect light of a particular wavelength distribution) and the color of the light source (which limits which wavelengths are actually present to be reflected). A tricky prospect for the brain.

The two cubes also demonstrate another perceptual principle. See the blue chips on the top of the left cube, and the yellow chips on the top of the right cube? They are identical, and appear as plain gray when the surrounding colors are removed. This phenomenon, called "color contrast," causes red apples to appear redder against a background of green leaves. More generally, it makes equal colors look different because of context.

Color contrast and color constancy show that our perception of color is not all that is seems. This chapter presents several of the color illusions that competed in the contest, as well as their neural bases.

BIRDS IN A CAGE

When you stare at a color image, its afterimage takes on a shade of its own. After-images are the consequence of a neural process called adaptation, by which neurons decrease their responses to unchanging sensory inputs. Once neurons have adapted, it takes a while for them to reset to their previous, responsive state. It is during this period that illusory afterimages appear. We see such images every day when we experience a temporary dark spot in our field of vision after briefly looking at the sun or at a bright lightbulb, or after being momentarily blinded by a camera flash. Gazing at any colored surface can also induce a vivid afterimage of the complementary color—that is, red versus green, or blue versus yellow. Imagine staring at a red surface. The cells in your retina that respond to red light will reduce their activity to save energy and to prepare themselves for detecting any future changes in redness. So, when you look away to a white background, your retina remains adapted to the red environment for a few seconds. With the red "subtracted" from the white, you will see red's opposite: green.

To try it out, stare at the red parrot for thirty seconds, then immediately look at the center of the empty birdcage. You should see a ghostly greenish parrot inside. Try the same with the green cardinal, and you should see a pink bird. A similar illusion is part of an exhibit at the Exploratorium museum in San Francisco.

COLOR DOVE ILLUSION

BY YUVAL BARKAN AND HEDVA SPITZER

TEL AVIV UNIVERSITY, ISRAEL

2009 SECOND PRIZE

Positive afterimages—which have the same color as the inducing image, rather than its opposite—can be captured from a surrounding color. Stare for about thirty seconds at the "target" on the bird in the left panel. While you keep your eyes on the dot, you may notice that the red background causes the white bird to fill in with a complementary blue-green color. Then look immediately at the same spot on the bird in the right panel. Removing the red background gives rise to a surprisingly strong and long-lasting red afterimage of the bird. To experience an even more striking version of this illusion with a "flying" bird, visit the Best Illusion of the Year Contest website.

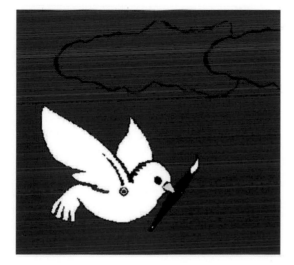
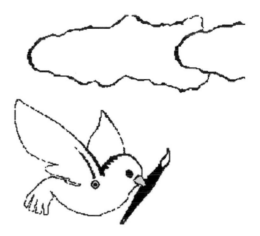

23

SHAPE-SPECIFIC AFTERIMAGES

BY ROB VAN LIER AND MARK VERGEER

RADBOUD UNIVERSITY, NIJMEGEN, THE NETHERLANDS

2008 FIRST PRIZE

In this illusion, a single multicolored image produces two afterimages of different colors, with each afterimage confined to a different shape. Fix your gaze on the black dot between the colored stars in the middle panel and stare at it for a full minute without moving your eyes. Then look at the empty outlines in the top panel. The left one fills in with a ghostly blue-green, and the right one looks reddish. When you look at the bottom panel, the colors are reversed. How does one image produce two afterimages of different colors? And how does the shape of the outline determine the filled-in color? This illusion demonstrates that patches of an afterimage can spread and merge to fill the contours of an outlined shape. The shape on the upper right takes on a reddish hue because it has the same outline as the complementary blue-green patches in the original color image. Likewise, the blue-green-tinged shape on the upper left matches the red patches in the original color image.

FLEXIBLE COLORS

BY MARK VERGEER, STUART ANSTIS, AND ROB VAN LIER

UNIVERSITY OF LEUVEN, BELGIUM; UNIVERSITY OF CALIFORNIA, SAN DIEGO, U.S.A.; RADBOUD UNIVERSITY, NIJMEGEN, THE NETHERLANDS

2014 SECOND PRIZE

Six years after they bagged the 2008 first prize for their work with afterimages, Vergeer and his colleagues extended the focus of their research to study how the contours of an image influence the way we see its colors. Paintings by Pablo Picasso and other artists suggest that coloring within the lines is not a strict requirement for our ability to assign color to shape. Vergeer and his colleagues set out to explore this in detail, and proved that our brain has an extraordinary ability to ascribe colors to relevant shapes in an image. Their illusion shows that a single image can lead to diametrically different color impressions. The left and right colored images in the middle row are identical, constructed by combining the color profiles of a picture of a forest and a picture of the Manhattan skyline. When semitransparent grayscale images (images in monochromous gray shades ranging from black to white—as seen, for instance, in black-and-white movies) of the forest or the skyline are overlaid on the color images (top row), our visual neurons seamlessly match the appropriate colors to the relevant outlines, ignoring the dissonant colors, and we clearly see one or the other—a suitably colored forest or a skyline—even though the color profiles of both scenes are still present in each image.

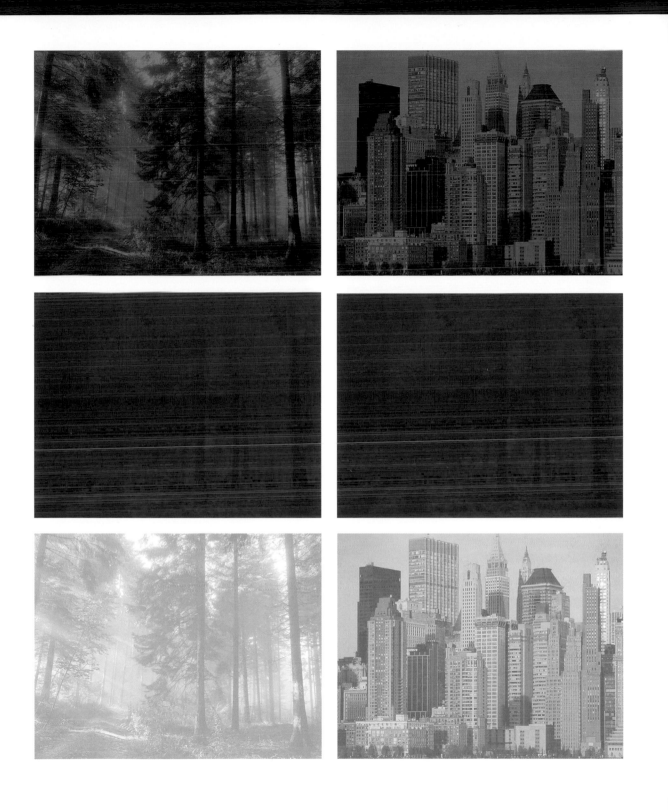

WHITE'S EFFECT
AND THE ILLUSION OF
THE YEAR LOGO

n 1979, the vision scientist Michael White described an illusion that changed visual science. In the top image, the gray bars on the left look darker than the gray bars on the right. In fact, all the gray bars are identical. Before White discovered this effect, brightness illusions were thought to result from opponent processes—that is, a gray object should look dark when surrounded by light, and light when surrounded by dark. But in this illusion, the darker-looking gray bars are surrounded by black, and the lighter-looking gray bars are surrounded by white. Although the brain mechanisms underlying White's Effect remain unknown, the illusion has bolstered new research avenues in visual perception—pioneered by the neuroscientist Dale Purves—based on the idea that we see things according to our brains' expectations.

Purves's idea is that the visual system has evolved to interpret the world according to empirical probability. In other words, our perception is consistent with the way things are most likely to be. Our experience of illusions such as White's Effect, it follows, depends on the context in which we view them, and the probability of all the possible interactions that our ancestors had with similar scenarios.

White's Effect also changes the appearance of colors. The logo for the Best Illusion of the Year Contest is an homage to both White's Effect (the trophy appears to be different colors behind the two curtains, though it's actually the same color throughout) and the famous Face/Vase Illusion, but with a trophy in place of the vase.

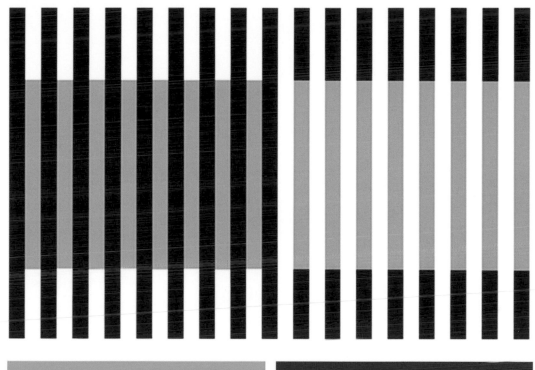

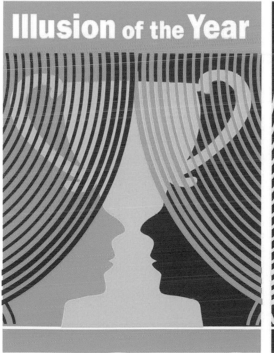

Illusion of the Year

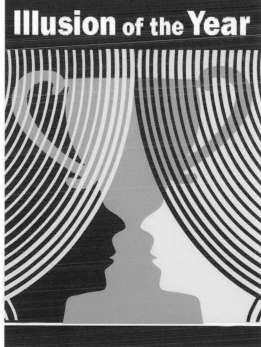

Illusion of the Year

SIZE ILLUSIONS

As both a tiny person in the country of Brobdingnag and a giant on the island of Lilliput, Lemuel Gulliver—the protagonist of Jonathan Swift's *Gulliver's Travels*—experiences firsthand that size is relative. When we cast a neuroscientific light on this classic book, it is clear to us that Swift, a satirist, essayist, and poet, knew a few things about the mind, too. Absolute size is meaningless to our brain: we gauge size by context. The same medium-sized circle will appear smaller when surrounded by large circles and bigger when surrounded by tiny ones, a phenomenon discovered by the German psychologist Hermann Ebbinghaus. Social and psychological contexts also cause us to misperceive size. Research shows that spiders appear larger to people who suffer from arachnophobia than to those who are unafraid of bugs, and that men holding weapons seem taller and stronger than men who are holding tools. Here we present a collection of illusions that will expand your horizons and shrink your confidence in what is real. Try these out for size!

DYNAMIC SIZE CONTRAST ILLUSION

BY GIDEON CAPLOVITZ AND RYAN MRUCZEK

UNIVERSITY OF NEVADA, RENO, AND SWARTHMORE COLLEGE, U.S.A.

2013 FINALIST

This illusion shows that a viewer's perception of an object's size radically varies as a function of background motion. When the background is growing, the object appears to shrink. Conversely, when the background is shrinking, the object appears to grow. Caplovitz and Mruczek's discovery suggests that our visual system integrates multiple sources of sensory information to determine the perceived size of an object. For example, the brain must consider the projected size of the object's image on the retina as well as its size relative to other objects in the scene. Extracting the information from the visual image is particularly challenging when the object is in motion, and doubly so when the observer's eyes pursue the moving object. One reason that might help explain why the Dynamic Size Contrast Illusion is so powerful is that items that move draw our attention more forcefully than stationary ones. Our own research showed that during magic performances, spectators tend to focus their attention on fluidly moving elements, such as the magician's hand, instead of the parts of the stage that remain still. In the Dynamic Size Contrast Illusion, our attention may focus preferentially on the moving background, maximizing our perception of the differences between the background and the object in the foreground. See a dynamic demonstration of this illusion at the Best Illusion of the Year Contest website.

Perception

Reality

⊢———————⊣
Looks bigger

⊢———————⊣
Looks smaller

THE DYNAMIC EBBINGHAUS ILLUSION

BY CHRISTOPHER BLAIR, GIDEON CAPLOVITZ, AND RYAN MRUCZEK

UNIVERSITY OF NEVADA, RENO, U.S.A.

2014 FIRST PRIZE

arlier we mentioned the classic Ebbinghaus Illusion, in which a circle surrounded by smaller circles looks bigger than the same circle surrounded by larger circles. This perceptual phenomenon proves that our experience of an object's size is relative to its visual context. Blair, Caplovitz, and Mruczek created an Ebbinghaus Illusion on steroids by combining it with the principles behind the Dynamic Size Contrast Illusion. The new and improved Ebbinghaus effect consists of a dynamic display with surrounding circles that expand and shrink while the central circle's size stays constant. The authors explained that the Dynamic Ebbinghaus Illusion is at least twice as strong as the original, static Ebbinghaus Illusion.

The illusion is even more powerful when you look at it from the corner of your eye, rather than directly. The reason could be that your peripheral vision is more sensitive to motion than your central—also called foveal—vision.

Your retina has a high-resolution central area called the fovea. The fovea sees an extremely small part of our visual field—just 0.1 percent, or the size of your thumbnail at arm's length—but its function is critical for everyday life, and particularly so for investigating fine details and small objects. Without a fovea, you wouldn't be able to read the newspaper, watch TV, drive a car, or interpret facial expressions.

The main reason you make eye movements is to target your fovea to the right place at the right time, a necessary condition to see in detail. Many of the neural calculations that control and direct your gaze rely on information from the non-foveal 99.9 percent of your visual field: the retinal periphery.

The periphery of your retina—though it produces lower-resolution vision than the fovea—has certain special abilities that help you to decide where to look next. For example, the periph-

Classic Ebbinghaus Illusion

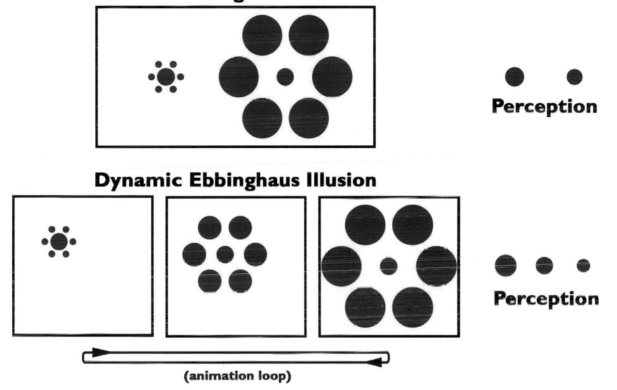

Perception

Dynamic Ebbinghaus Illusion

Perception

(animation loop)

ery detects motion and gross details better than the fovea, and is more sensitive to flickering light and changes in brightness and contrast. This is the reason why fluorescent lighting sometimes flickers when you see it out of the corner of your eye, but not if you look at the light fixtures directly. So it should come as no surprise that the brain circuits processing peripheral visual information are susceptible to special kinds of illusions, especially those that involve motion and other dynamic changes. See this illusion in action at the Best Illusion of the Year Contest website.

FAT FACE THIN ILLUSION

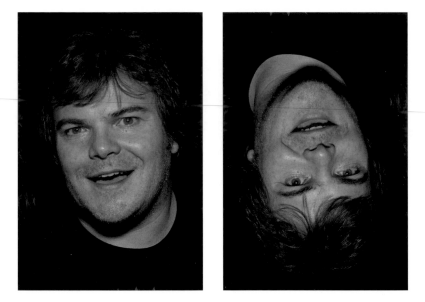

BY PETER THOMPSON

UNIVERSITY OF YORK, U.K.

2010 FINALIST

The Fat Face Thin Illusion shows two photographs that are identical, although the upside-down face appears strikingly slimmer than the right-side-up version. One possible explanation is that it is easier for the brain to recognize distinctive facial features, such as chubby cheeks, when they are viewed in the normal upright position. Research has shown that face-selective neurons of the human brain respond best to upright faces—perhaps because there has been no evolutionary pressure to recognize faces upside-down. These same neurons may encode various facial properties—like chubbiness—and be less capable of doing so accurately when faces are upside-down. If so, all upside-down faces could end up looking more similar to one another than if they were upright.

HEAD SIZE ILLUSION

BY KAZUNORI MORIKAWA AND ERI ISHII

OSAKA UNIVERSITY, JAPAN

2012 FINALIST

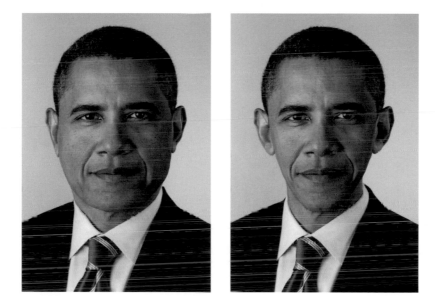

The two Barack Obama portraits above are identical except that the one on the left has a wider jaw and fuller face than in reality. The top of the head appears fatter, too, but it is not. The Head Size Illusion demonstrates that the brain does not determine the size of visual stimuli in isolation from one another; it considers objects and features in relation to those nearby in the scene. The illusion occurs in everyday life, Morikawa said, and offers an opportunity for those who wish to alter their appearance. "If one part of your face or body appears wider or thinner than average, other parts appear wider or thinner, too," he explained. "You can take advantage of such illusions to make yourself look better, using effective makeup and clothing."

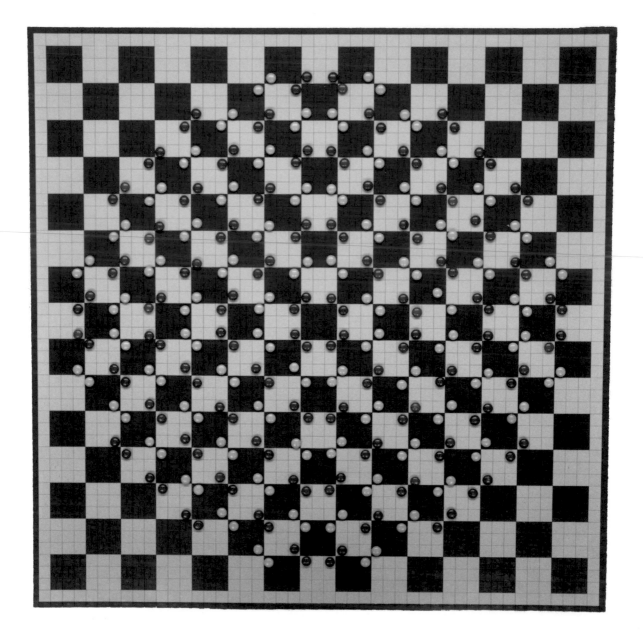

SHAPE ILLUSIONS

Visual perception begins when our retinas locate the edges of objects in the world. "Downstream" neural mechanisms, which are activated after visual signals leave the retina, analyze the information at the edges of objects to fill in their insides. That's how we perceive surfaces. But what happens when these edges—the fundamental building blocks of our visual reality—are tweaked? Our brain's ability to represent reality accurately no longer functions, and the surfaces of objects appear to warp. Seemingly small mistakes in edge alignment lead to the distorted perception of an illusory world. The illusions in this chapter reveal how these mental building blocks work together to assemble an object. Surprising inaccuracies in some of these mechanisms result in weird and wonderful misinterpretations of the shapes we see in our lives.

IT'S A CIRCLE, HONEST!

BY DAVID WHITAKER

UNIVERSITY OF BRADFORD, U.K.

2007 FINALIST

ubtle local effects can have major global consequences on how we perceive a shape, even one as simple as a circle. The circle at the top appears round only if you look directly at it. If you view it through your peripheral vision, it has corners! When you use the center of your vision—where your visual neurons have small, high-resolution windows on the world that scientists call "receptive fields"—you can see the curves that form the circle, and also the checkerboard pattern on its surface. In the periphery of your vision, however, visual neurons see the world through larger, low-resolution receptive fields that poorly appreciate the circle's subtle curves while favoring its high-contrast large checks. And because the checks form diagonal lines when blurred, you see a diamond shape instead of a circle out of the corner of your eye. In contrast, when you view the lower circle through the center of your vision, you perceive it as roughly circular with a checkerboard surface. But when you view it peripherally, it looks much more rounded. That's because the smaller elements that form the circle smear out to gray in the larger peripheral receptive fields, and so the circular interpretation of the ring dominates your perception.

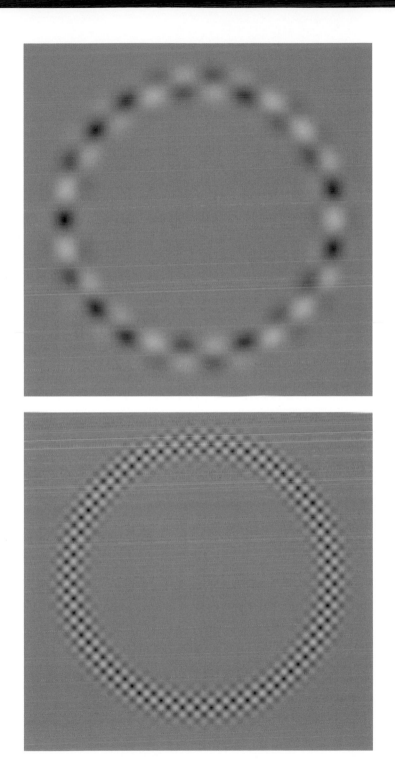

COFFER ILLUSION

BY ANTHONY NORCIA

SMITH-KETTLEWELL EYE RESEARCH INSTITUTE, U.S.A.

2007 FINALIST

nformation transmitted from the retina to the brain is constrained by physical limitations, such as the number of nerve fibers in the optic nerve (about a million wires). If each of these fibers were responsible for producing a pixel (a single point in a digital image), you *should* have lower resolution in your everyday vision than in the images from your iPhone camera, but of course this is not what we perceive. One way our visual system overcomes these limitations—to present us with the perception of a fully realized world, despite the fundamental truth that our retinas are low-resolution imaging devices—is by disregarding redundant features in objects and scenes. Our brains preferentially extract, emphasize, and process those unique components that are critical to identifying an object. Sharp discontinuities in the contours of an object, such as corners, are less redundant—and therefore more critical to vision—because they contain more information than straight edges or soft curves. The perceptual result is that corners are more salient than non-corners. The Coffer Illusion contains sixteen circles that are invisible at first sight, obscured by the rectilinear shapes in the pattern. The illusion may be due, at least in part, to our brain's preoccupation with corners and angles.

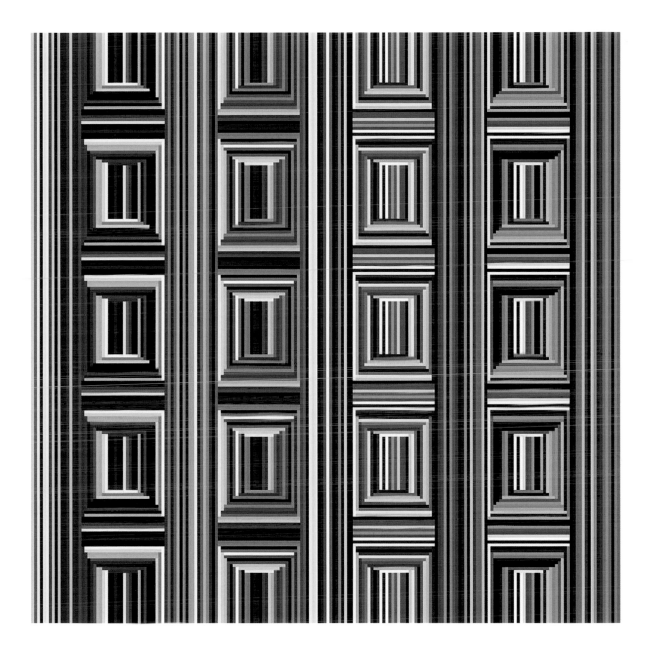

THE HEALING GRID

BY RYOTA KANAI

UTRECHT UNIVERSITY, THE NETHERLANDS

2005 FINALIST

Let your eyes explore this image freely and you will see a regular pattern of intersecting horizontal and vertical lines in the center, flanked by an irregular grid of misaligned crosses to the left and right. Choose one of the intersections in the center of the image and stare at it for thirty seconds or so. You will see that the grid "heals" itself, becoming perfectly regular all the way through. The illusion derives, in part, from "perceptual fading," the phenomenon in which an unchanging visual image fades from view. When you stare at the center of the pattern, the grid's outer parts fade more than its center due to the comparatively lower resolution of your peripheral vision. The ensuing neural guesstimates that your brain imposes to "reconstruct" the faded outer flanks are based on the available information from the center, as well as your nervous system's intrinsic tendency to seek structure and order, even when the sensory input is fundamentally disorganized. Because chaos is inherently unordered and unpredictable, the brain must use a lot of energy and resources to process truly chaotic information (like white noise on your TV screen). By simplifying and imposing order on images like this one, the brain can reduce the amount of information it must process. For example, because the brain can store the image as a rectilinear framework of white rows and columns against a black background—rather than keeping track of every single cross's position—it saves energy and mental storage space. It also simplifies your interpretation of the meaning of such an object.

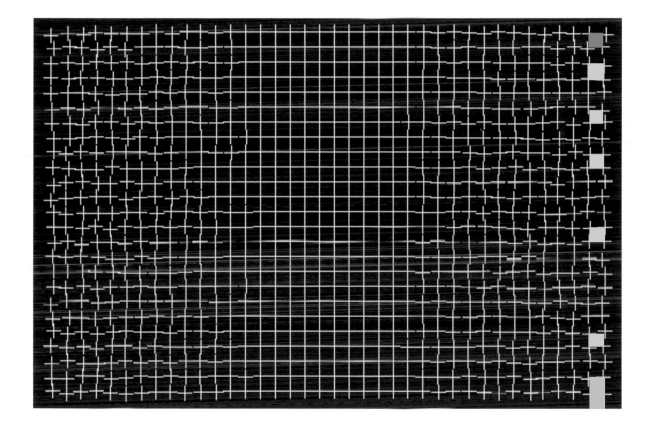

SHEPARD'S SARCOPHAGI

The shape on the upper right appears longer and narrower than the one on the upper left. Or is it? Photocopy this page, and then grab a pair of scissors and cut around the trapezoid shapes containing each sarcophagus. Now line them up and superimpose them. Both shapes are exactly the same size. The effect is a version of the classic Shepard Tabletop Illusion, also featured here, named after its creator, the cognitive scientist Roger Newland Shepard. The illusion consists of two polygons with very different appearances (one looks much longer and thinner than the other), even though the two shapes are identical. The confusion results from our perceptual inferences about actual objects. If the two polygons corresponded to real tabletops, they would have to be physically different. The Shepard Tabletop Illusion is, in a sense, an illusion of perspective. The inferences we make about the shapes of the polygons also apply to any images within them. This is why the sarcophagi inside the trapezoids appear distorted too.

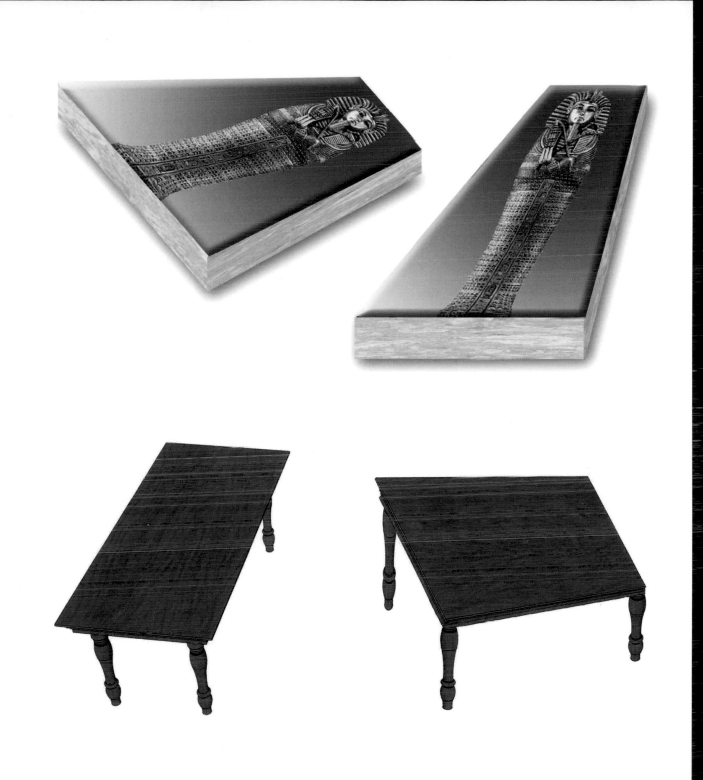

ANOTHER TURN

BY LYDIA MANIATIS

AMERICAN UNIVERSITY, U.S.A.

2009 FINALIST

The vision researcher Lydia Maniatis presented a novel variant of the Shepard Tabletop Illusion, in which not just two but *three* identical polygons look diametrically different from each other. The three red-and-blue-colored box tops are identical: all the blue lines are the same length, and so are all the red lines. If you don't believe it, measure the lines, or cut and rotate the boxes, to convince yourself!

STRETCHING OUT
IN THE TUB

BY LYDIA MANIATIS

AMERICAN UNIVERSITY, U.S.A.

2010 FINALIST

ydia Maniatis discovered this illusion serendipitously. Walking down the street one day, she noticed an odd effect as she passed a bathtub company's billboard. As she proceeded from one end of the huge image to the other, the bathtub seemed, impossibly, to stretch; when approached from the other direction, it appeared to shrink. Intrigued, she walked past the ad again and again. From one end, the foreshortened tub looked like a large sink. But as Maniatis approached the other end, the "sink" slowly stretched back into a tub. Her visual system made assumptions about the identity of the object from each angle, giving rise to different 3-D perceptions at each location along the billboard.

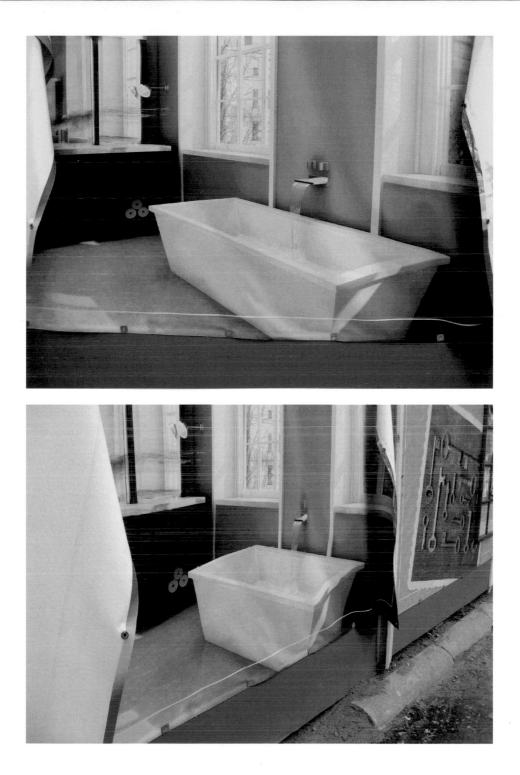

THE MORE-OR-LESS MORPHING FACE ILLUSION

BY ROB VAN LIER AND ARNO KONING

DONDERS INSTITUTE, THE NETHERLANDS

2011 FINALIST

Rob van Lier and Arno Koning of the Donders Institute for Brain, Cognition and Behaviour, a research center in The Netherlands, showed the audience the image of a face. They superimposed a circling red dot over the face and asked the audience to keep their eyes on the dot. After a short while, the dot disappeared and the picture appeared to morph from a male face to a female face and back to male. Then the red dot reappeared, and the face stopped morphing. In reality, the face had been morphing continuously the entire time. It only appeared unchanging when the viewers focused on the moving red dot. Van Lier demonstrated that this illusion also works for a face with shifting emotions and ages, and even when he used a famous face, such as Barack Obama's, morphing between happy and sad expressions. The misperception could be due to how various visual features engage our attention. Our own research has shown that when we focus on a moving object, attention mechanisms in our visual cortex work to suppress everything else. For this illusion, closely watching the moving dot may suppress neural activity in the fusiform gyrus, the part of the brain that processes faces, causing us to overlook the changing characteristics.

Perception

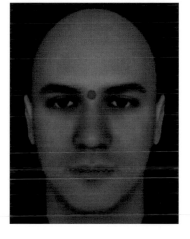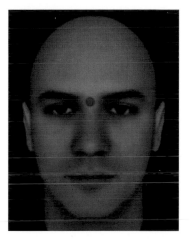

Time

Reality

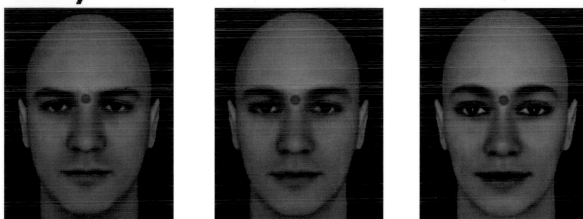

Time

YANG'S IRIS ILLUSION

BY JISIEN YANG AND ADRIAN SCHWANINGER

UNIVERSITY OF ZURICH, SWITZERLAND; NATIONAL CHUNG-CHENG UNIVERSITY, TAIWAN; MAX PLANCK INSTITUTE, GERMANY

2008 FINALIST

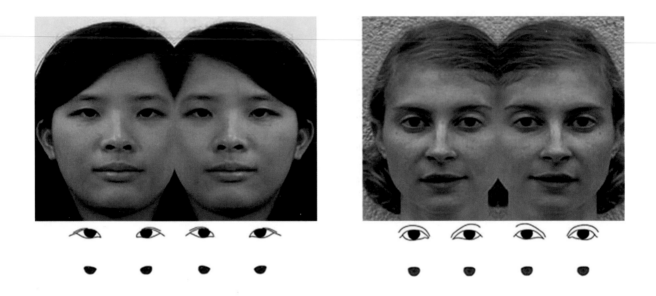

This illusion shows that overall context affects how we perceive specific facial details. The shape of the eyelids and face in these two photos seems to affect the distance between the irises. Consider the pair of Asian faces: the distance between the left eye of the right face and the right eye of the left face seems short. For the Caucasian faces, the separation seems wider. If you compare the photos with the diagrams of the eyes and irises with all facial context removed, it is clear that the irises are equally spaced.

ILLUSORY PYRAMID

BY PIETRO GUARDINI AND LUCIANO GAMBERINI

UNIVERSITY OF PADUA, ITALY

2007 SECOND PRIZE

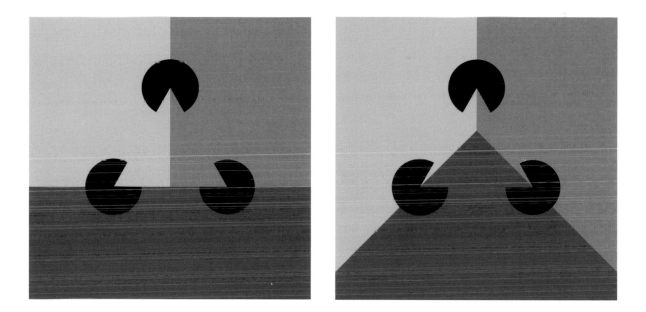

The Illusory Pyramid is a novel variant of the classic Kanizsa Triangle, in which a phantom triangle arises from the placement of three Pac-Man shapes at its imaginary corners. Guardini and Gamberini's illusion adds a background formed by three patches of different shades of gray. One variation of the three gray segments produces the illusory triangle; another variation produces an illusory pyramid. We perceive the 3-D shape of the pyramid only because our brains impose this imaginary shape on a very sparse field of 2-D data. This illusion shows that much of our perception is an elaborate construct, based on scarce physical foundations.

SKYSCRAPERS AND CLOUDS

BY SANDRO BETTELLA, CLARA CASCO, AND SERGIO RONCATO

UNIVERSITY OF PADUA, ITALY

2008 FINALIST

The vertical sides of the skyscrapers seem to bulge out and contract relative to the clouds in the background, but the width of each building is actually constant. The neural bases of this illusion are unknown, but the visual neuroscientist Jens Kremkow, working with Jose Manuel Alonso and Qasim Zaidi at the State University of New York, discovered a similar phenomenon that goes back to the Italian astronomer Galileo Galilei. It turns out that our eyes see lightness and darkness in a surprising way.

Galileo was puzzled by the fact that planets appeared different depending on whether he looked at them with the naked eye or through a telescope. He wrote that the planets seemed "expanded" and had "a radiant crown" when viewed directly, making Venus look eight to ten times larger than Jupiter, even though Jupiter is the larger planet. Though Galileo realized that his eyes, rather than the planets themselves, were responsible for the change, he did not understand why or how. He mused over whether the effect occurred "either because [the planets'] light is refracted in the moisture that covers the pupil, or because it is reflected from the edges of the eyelids and these reflected rays are diffused over the pupil, or for some other reason." The Renaissance artist and engineer Leonardo da Vinci had noticed a similar effect. While looking at a canvas, he observed that dark objects on a light background seemed more defined than light objects on a dark background. And more than three centuries later, Hermann von Helmholtz—the venerable nineteenth-century German physician-physicist—also described the phenomenon in his *Treatise on Physiological Optics* as the "irradiation effect."

It took modern neurophysiological research to understand the neural mechanisms that affect the perceived size of black and white objects. Kremkow and his colleagues examined the responses of neurons in the visual system of the brain—to both light stimuli and dark stimuli—

and discovered that whereas dark stimuli generate faithful neural responses that accurately represent their size, light stimuli produce exaggerated neural responses that make the objects appear larger. So white spots on a black background look bigger than black spots of the same size on a white background, and Galileo's glowing planets are not really as big as they might appear to the unaided eye.

The irradiation effect influences our perception of all sorts of objects and textures, and explains why it is easier to read this very page with black-on-white lettering, rather than white-on-black (a well-known and previously unexplained fact). It could even illuminate (pun intended) why skyscrapers seem to expand and shrink depending on their background. See a dynamic version of this illusion at the Best Illusion of the Year Contest website.

CUBISTIC LANDS

**BY SANDRO BETTELLA, GIANLUCA CAMPANA,
CLARA CASCO, AND SERGIO RONCATO**

UNIVERSITY OF PADUA, ITALY

2009 FINALIST

ur vision has the amazing power to determine the shape and depth of objects based on clues from the environment. Think of how the appearance of an object changes, in a predictable way, as a function of lighting conditions. For instance, imagine seeing this book first inside the house and then outside, in the sunlight. We can tell that both the inside book and outside book are the same object, but it's a very complex computation: shadows fall on surfaces in different directions, the contrast of shading is much higher outside, the color of the light is different. It's a miracle that we can recognize the same shape in these two different environments!

So how does the brain do it? This illusion by Bettella and his colleagues gets at the heart of the issue. Our visual system naturally interprets the pattern of repeating shapes as a series of steps lit from above, as if by the sun. Nobody knows exactly how the visual system computes shading, but we do understand some of the rules concerning how we perceive an image such as this. Our brain normally assumes that contours of the same characteristics belong to the same surface. Here we perceive the dark-shaded areas as being a single surface, and we make a similar assumption for the "sunlit" areas of the image. This grouping creates the impression of depth and allows us to see a folded shape resembling steps. The same processes help our brains determine the brightness of the light (which, in turn, helps us decide what is and what is not a shadow) versus the color of the object's surface itself.

AMBIGUOUS ILLUSIONS

Ambiguous illusions occur when you can interpret a single image in more than one way. Many contemporary examples hark back to a simple sketch by the English artist William Ely Hill, titled *My Wife and My Mother-in-Law*, which was published in the magazine *Puck* in 1915. In 1930, the experimental psychologist Edwin Boring of Harvard University brought the illustration to the attention of psychologists around the world. Boring argued that unlike other ambiguous figures, such as the Face/Vase illusion—where a dividing line separates the left and right face silhouettes from the central chalice—the wife and mother-in-law depictions infiltrate each other without an obvious visual barrier between them. In Boring's words, the drawing "shows in one figure the left profile of a young woman, three-quarters from behind. The other figure is an old woman, three quarters from the front. The ear of the 'wife' is the left eye of the 'mother-in-law'; the left eyelash of the former is the right eyelash of the latter; the jaw of the former is the nose of the latter; the neck-ribbon of the former, the mouth of the latter." Boring's vivid description of the ambiguous face launched a thousand experiments in perceptual alternation. This research aimed to find out how it is possible for the same physical image to generate two distinct and incompatible perceptions, and what changes in neural activity underlie the back-and-forth switches between one interpretation and the other. Almost forty years later, the vision scientist Gerald H. Fisher introduced a third figure, representing an old man, to create a triple-ambiguous image.

MASK OF LOVE

BY GIANNI SARCONE, COURTNEY SMITH, AND MARIE-JO WAEBER

ARCHIMEDES LABORATORY PROJECT, ITALY

2011 FINALIST

This illusion was discovered in an old photograph of two lovers sent to Archimedes' Laboratory, a consulting group in Italy that specializes in perceptual puzzles. Gianni Sarcone, the leader of the group, saw the image pinned to the wall and, being nearsighted, thought it was a single face. After putting on his eyeglasses, he realized what he was looking at. The team then superimposed the beautiful Venetian mask over the photograph to create the final effect.

This type of illusion is called "bistable" because, as in the classic Face/Vase illusion, you may see either a single face or a couple, but not both at once. Our visual system tends to see what it expects, and because only one mask is present, we assume at first glance that it surrounds a single face.

GHOSTLY GAZE

BY ROB JENKINS

UNIVERSITY OF GLASGOW, U.K.

2008 SECOND PRIZE

Not knowing where a person is looking makes us uneasy. That's why speaking with somebody who is wearing dark sunglasses can be awkward. And it is why someone might wear dark sunglasses to look "mysterious." The Ghostly Gaze Illusion, created by Rob Jenkins, takes advantage of this unsettling effect. In this illusion, twin sisters appear to look at each other when seen from afar. But as you approach them, you realize that the sisters are looking directly at you! The illusion is a hybrid image that combines two pictures of the same woman. The overlapping photos differ in two important ways: their spatial detail (fine or coarse) and the direction of their gaze (sideways or straight ahead). The images that look toward each other contain only coarse features, whereas the ones that look straight ahead are made up of sharp details. When you approach the pictures, you are able to see all the fine detail, and so the sisters seem to look straight ahead. But when you move away, the gross detail dominates, and the sisters appear to look into each other's eyes. In another example of a hybrid image, a ghostly face appears to look to the left when you hold the page at normal reading distance. Step back a few feet, however, and she will look to the right.

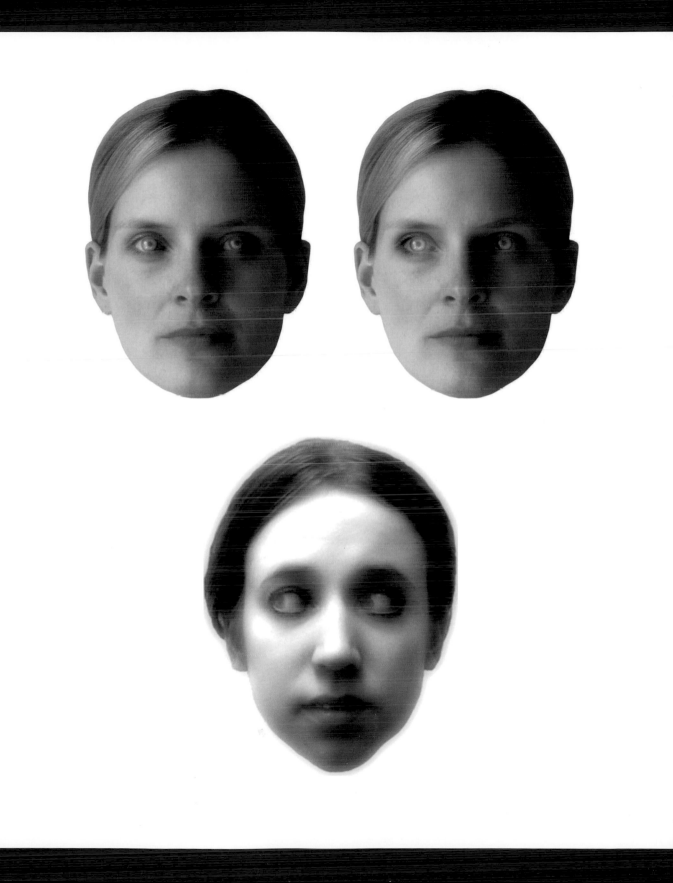

6

PERSPECTIVE AND DEPTH ILLUSIONS

Your perspective on the world dictates how you see objects. When visual targets are far away from you, they project images on your retinas that are smaller than the images projected by objects that are nearby. So when an object's retinal image shrinks, your brain assumes that the smaller image corresponds to a greater intervening expanse between you and the object. The same geometry explains why parallel lines—such as train tracks—appear to converge as they recede. That's just one way your visual system uses your viewpoint to help construct your perception of 3-D objects. We say "construct" because the visual system has no direct access to 3-D information in the world. Your perception of depth integrates many cues in addition to perspective, including stereopsis (our left and right eyes receive horizontally displaced images of the same object; our brain uses this "horizontal disparity" as a main mechanism behind our perception of depth), occlusion (objects near us occlude, or block, objects farther away), chiaroscuro (the contrast of an object as a function of the position of the light source), and sfumato (the feeling of depth produced by the interplay of in- and out-of-focus elements in an image, as well as from how transparent or opaque the atmosphere is). By combining these indicators, your brain forms an object's shape in 3-D space.

67

THE LEANING TOWER ILLUSION

BY FREDERICK KINGDOM, ALI YOONESSI, AND ELENA GHEORGHIU

McGILL UNIVERSITY, CANADA

2007 FIRST PRIZE

How could we have missed it? Hundreds, perhaps thousands, of visual scientists, psychologists, neuroscientists, artists, architects, engineers, and biologists all missed it—until 2007. The "it" in question is the Leaning Tower Illusion, discovered by Frederick Kingdom, Ali Yoonessi, and Elena Gheorghiu. In this illusion, two identical side-by-side images of the same tilted and receding object appear to be leaning at two different angles. This amazing effect was first noticed in images of the famed Leaning Tower of Pisa, but it also works

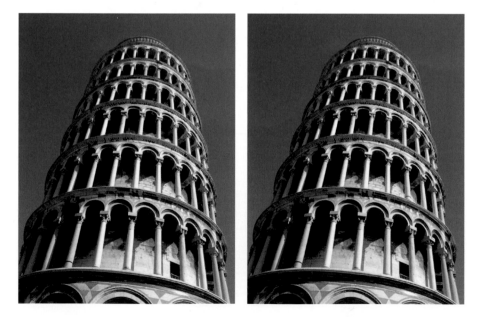

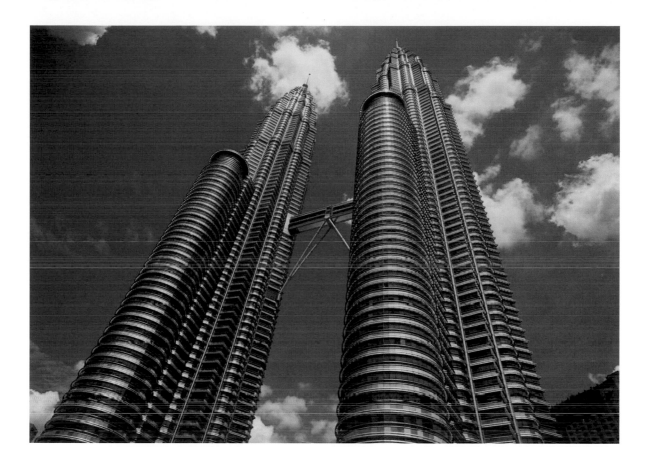

with paired images of other receding objects. Though the Leaning Tower Illusion is one of the simplest visual tricks, it is also one of the most profound for what it adds to our understanding of depth perception. This is why vision scientists still shake their heads in disbelief that they did not notice the illusion earlier. Kingdom and his colleagues introduced the illusion at the 2007 Best Illusion of the Year Contest, where it won first prize.

On the opposite page, the tower on the right appears to lean more than the tower on the left—but these two photographs of the Leaning Tower of Pisa are duplicates. Because the two Pisa towers pictured in the paired images do not converge as they recede, as they would if standing side by side in front of our eyes, the brain mistakenly perceives them as diverging. In contrast, when we look at a single photograph showing two actual parallel towers, such as the Petronas Twin Towers in Kuala Lumpur, we see the buildings converge in the distance as they recede, and therefore we perceive them as parallel.

Further analysis of similar images indicates that the phenomenon applies to all sorts of

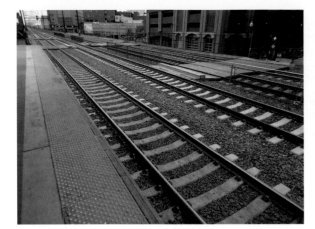 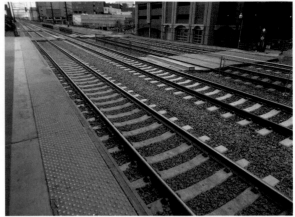

receding objects, not only those that recede in height. It is hard to believe, but these are actually identical images of parallel train tracks. Although the angles of the train tracks are the same in both images, the brain perceives them as being quite different.

The Leaning Tower Illusion is so central to our visual system that it works even with simple depictions of 3-D objects receding into the distance. The parallel lines corresponding to the long edges of the checkered box on the right seem to diverge; that is, the box appears wider at the back than it does at the front, though in fact the back and front are precisely the same width.

The Leaning Tower Illusion does not occur when we view two leaning Japanese manga girls, even though the two cartoon images are tilted. The reason is that the cartoon girls do not appear to recede in depth, so our brain does not expect them to converge in the distance. This phenomenon demonstrates that the brain applies its depth-perception toolkit only in specific situations, depending on the object.

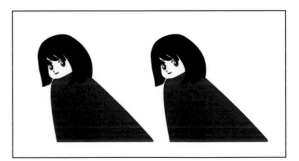

A TURN
IN THE ROAD

BY KIMBERLEY ORSTEN AND JAMES POMERANTZ

RICE UNIVERSITY, U.S.A.

2014 THIRD PRIZE

I n 2014, Orsten and Pomerantz used the principles underlying the Leaning Tower Illusion to show that two different images can look identical (scientists call these metamers), and that, conversely, two images that are physically the same can look different (anti-metamers). Of the three images below, which is the odd man out? It's probably not your first guess. Orsten and Pomerantz explained that our visual system usually does a good job when interpreting true 3-D objects, but has difficulty interpreting 2-D representations of 3-D objects such as drawings.

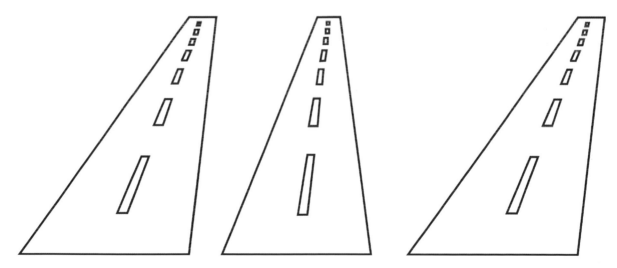

The left and central roads look the same. In reality, the left and right roads are identical, and the central road is different.

AGE IS ALL
IN YOUR HEAD

BY VICTORIA SKYE, U.S.A.

2014 FINALIST

The magician, photographer, and illusion creator Victoria Skye was having a hard time taking a picture of a photo portrait of her father as a teen. The strong overhead lighting was ruining the shot, so she tilted the camera to avoid the glare, first one way and then the other. As she moved her camera back and forth, she saw her father morph from teen to boy and then to adult.

Skye's illusion is an example of anamorphic perspective. By tilting her camera, she created two opposite vanishing points, producing the illusion of age progression and regression. In the case of age progression, the top of the head narrows and the bottom half of the face expands, creating a stronger chin and a more mature look. In the case of age regression, the opposite happens: the forehead expands and the chin narrows, producing a childlike appearance.

Skye thinks that her illusion may explain why, when we look at ourselves in the mirror, we sometimes see our parents, but not always. "I wonder if that is what happens to me when I look in the mirror and see my mom. Do I see her because I tilt my head and age myself just as I did with the camera and my dad?" she asked.

THROUGH THE EYES
OF GIANTS

ARASH AFRAZ AND KEN NAKAYAMA

**MASSACHUSETTS INSTITUTE OF TECHNOLOGY
AND HARVARD UNIVERSITY, U.S.A.**

2013 THIRD PRIZE

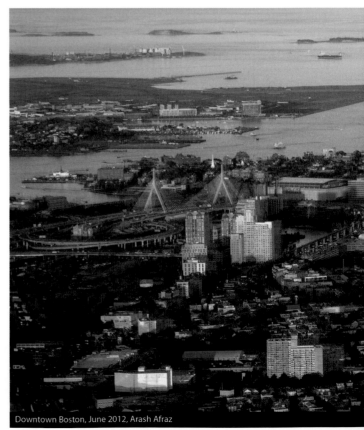

Downtown Boston, June 2012, Arash Afraz

Do you have any idea how hard it is for an Iranian national to rent a small plane for the purpose of "taking pictures" of skyscrapers in Boston? Arash Afraz, a researcher at MIT, and two of his Iranian friends found out the hard way—faster than you can say "post-9/11 Guantánamo strip search"—to bring us this amazing illusion. Afraz, working with Ken Nakayama of Harvard University, developed an unconventional method of creating stereoscopic anaglyph photographs, also called 3-D photographs, on a massive scale, bagging the third prize in 2013.

We perceive most everyday objects as 3-D structures because the separation between our eyes produces very different images on our two retinas. For small-to-medium-sized objects, our visual system uses this ocular disparity to produce stereovision. But very big, faraway objects, such as a city skyline, generate identical images on both eyes, and we do not experience stereoscopic perception. Until

74

now. Afraz and Nakayama's images allow us to see a full city in stereovision. To create this illusion, Afraz snapped pairs of large-scale photo shots, hundreds of meters apart, from his airplane. That's about three thousand times larger than the distance between your eyes. The result offers a glimpse of how Boston's cityscape would look through the eyes of a giant who perceived the skyline stereoscopically. View the image below while wearing red/cyan anaglyph 3-D glasses and you'll see Boston from just such a perspective. The buildings and other city-scale objects will appear miniaturized, as if in a detailed toy-set model. This is because our natural stereovision occurs only when we view relatively small objects. Seeing a huge object in stereo creates the illusory perception that the object is a miniature. Afraz and Nakayama's illusion shows that visual perception does not derive passively from physical parameters such as the horizontal disparity between two images, but is instead an active interpretation of the external world, based on both sensory evidence and prior assumptions.

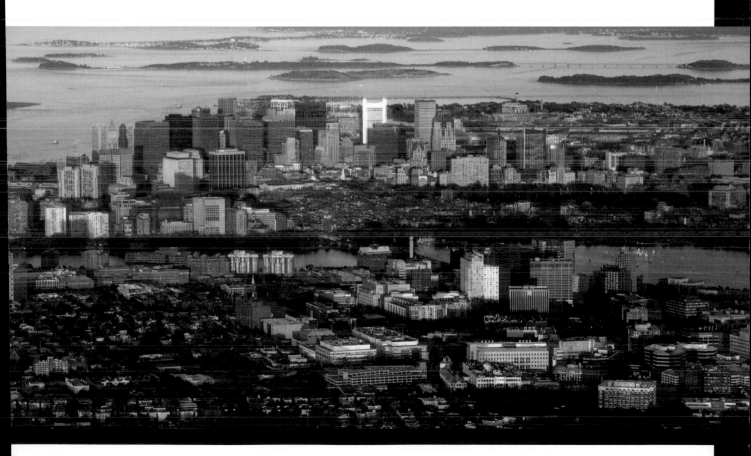

STEREO VISION PRODUCES NEW ILLUSORY CONTOURS!

DAVI GEIGER AND HIROSHI ISHIKAWA

NEW YORK UNIVERSITY, U.S.A., AND NAGOYA CITY UNIVERSITY, JAPAN

2009 FINALIST

ur visual system fills in all sorts of perceptual gaps. In the central image below, a white hexagon appears between the stars, even though its edges are incomplete; our brain sees past the broken lines to discern the shape. This type of neural shortcut is critical to shape perception in a noisy visual world. Geiger and Ishikawa's illusion shows that our visual system can use stereoscopic information gleaned from the two eyes' inputs to enhance our discernment of the shape of an illusory object—or, in this case, objects! With the help of stereoscopic visual cues, our brains can sense illusory shapes that don't exist on a single plane. To try it, you will need either to cross or to uncross your eyes, so that two of the three images slide over each other and fuse into a single image. You can either diverge or converge your eyes to combine the left and central images or the central and right images (whichever is easier for you). The perceptual outcome will be the same in both cases: two illusory triangles (one pointing down, one pointing up) formed on two different stereoscopic depth planes. Notice that the two triangles don't exist in either image when viewed without stereoscopic convergence.

HIDDEN STRENGTH OF THE CLASSICAL SIMULTANEOUS CONTRAST ILLUSION

PAWAN SINHA

MASSACHUSETTS INSTITUTE OF TECHNOLOGY, U.S.A.

2006 FINALIST

Simultaneous contrast is an illusory effect demonstrating that the perceived brightness of an object is relative to its surroundings. See the small central rectangle in the left-hand image below, representing the classical simultaneous contrast illusion. You may sense that the rectangle's left side is lighter than its right side. This occurs because your brain calculates brightness as a function of the surrounding context.

But now consider the two small gray squares in the right-hand image below. They are also the same shade of gray, but they look much more different in apparent brightness. Sinha realized that if you bring the two gray squares right next to each other by crossing your eyes and aligning the left and right colored dots with their corresponding counterparts, the two gray halves of the resulting rectangle remain strongly dissimilar, even though now they have the same visual proximity as in the classic simultaneous contrast illusion. One possible explanation is that the brain circuits that calculate brightness do not work across the two eyes.

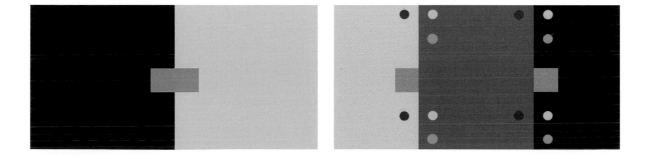

MOTION ILLUSIONS

Every nervous system in nature has evolved to detect change. Static environments hold little interest and pose no threat to our survival, so our brains have learned to ignore them. Indicating change alone—as opposed to constantly signaling lack thereof—results in great metabolic savings for our bodies. Your brain represents only 2 percent of your total weight, but it uses more energy than any other organ, accounting for up to 20 percent of your body's total. But even that much energy is not enough to process the vast amount of information that constantly bombards your senses. Of the many evolutionary shortcuts your nervous system has developed, a main one is to avoid bothering with things that don't change.

In contrast, change—especially if sudden—is extremely stimulating to our senses, and we have evolved to detect it. Change could mean that . . . a predator is approaching! Or that prey is getting away! The downside is that, without change, we cannot perceive the world around us. Our brains turn off in the absence of variation. You may think that this is impossible—after all, if you sit still in a quiet room, your surroundings don't just disappear. But the fact is that we can only see immobile objects because our eyes are always moving. Even when we think that our gaze is perfectly frozen, we still make constant microscopic eye movements, introducing the change we require to perceive reality.

Our need for motion in order to see—be it motion in the world, or our own eye movements—presents the visual system with an interesting challenge. How can you tell if it is the world that is moving, or your eyes? To get a sense of this problem, tap lightly and quickly on the outer corner of your upper eyelid, so that your eyeball moves back and forth a tiny bit. The visual world immediately becomes unstable and shaky. But if you were to move your eyes by the same amount voluntarily, the scene in front of you would appear perfectly steady. This indicates that the brain usually suppresses self-generated motion from eye movements, but it registers actual motion that occurs in the world. To enact this differential suppression, the brain must tell apart one kind of motion from the other. Previous studies had concluded that the primary visual cortex could not distinguish the motion of your eyes from motion in the world, but our own research has shown that the neural mechanisms needed to do so are already present at this early brain level. The perceptual distinction resulting from the underlying circuitry is often flawless, but certain repetitive visual patterns, such as the ones presented in this chapter, push the limits of our perception and make us think that the world is in motion—when only our eyes are moving.

THE SPINNING DISKS ILLUSION

BY JOHANNES ZANKER

ROYAL HOLLOWAY, UNIVERSITY OF LONDON, U.K.

2005 FINALIST

In the Spinning Disks Illusion, grayscale gradients in the shape of disks are arranged in concentric circles that seem to spin slowly, instead of appearing completely motionless—which they actually are! The illusion is caused by involuntary eye movements: each eye motion moves the image onto a new population of retinal photoreceptors. If you stare at the red central dot, carefully holding your eyes in place, the illusory motion will cease.

THE *ENIGMA* ILLUSION

Look at the center of the left-hand image below and notice how the concentric green rings appear to fill with rapid illusory motion, as if millions of tiny cars were driving hell-bent for leather around a track. For almost two hundred years, artists, psychologists, and neuroscientists debated whether this type of striking illusory motion originates in the eye or in the brain; for almost two decades, the controversy centered on the motion perceived in a similar painting, called *Enigma*, created by Isia Leviant, an artist associated with the Op Art

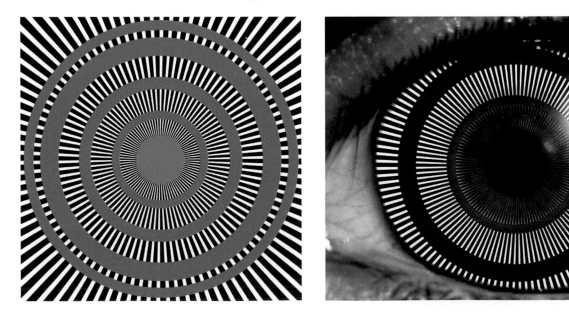

movement. Op Art started in the 1960s with the explicit intent to examine illusory perception. Our colleague Jorge Otero-Millan created this particular image as a reinterpretation of Leviant's *Enigma*.

Does the illusion originate in the mind or in the eye? The evidence was conflicting until we found, in collaboration with Xoana Troncoso and Otero-Millan, that the illusory motion is significantly driven by microsaccades: small involuntary eye movements that occur when we fix our eyes on a target.

Some years ago, Susana noticed that the speed of illusory motion in *Enigma* was not immutable across time, but depended on how precisely she fixed her gaze. If she held her eyes very still while staring carefully at the center of the image, the motion seemed to decrease and would occasionally come to a full stop. Conversely, when she focused her eyes loosely, the movement sped up. Our previous research had shown that strictly focusing your eyes suppresses the production of microsaccades, with dramatic effects on visibility. It followed that microsaccades may drive the perception of *Enigma*'s illusory motion under normal, or loosely focused, fixation conditions.

To test this idea, we asked volunteers to stare steadily at a small spot at the center of an *Enigma*-like pattern while we tracked their eye movements. Subjects pressed a button whenever the motion appeared to slow down or stop and released the button whenever the motion sped up. As we predicted, microsaccades increased in frequency just before people saw faster motion, and became sparser just prior to the slowing or halting of the motion. The results, published in 2008, proved for the first time that this type of illusory motion starts in the eye. Otero-Millan's *Enigmatic Eye* (right image on opposite page), also a tribute to *Enigma*, reflects the role of eye movements in the perception of the illusion.

The precise brain mechanisms that cause us to perceive the *Enigma* Illusion are still unknown. One possibility is that microsaccades—and perhaps other eye movements, too—produce small shifts in the geometric position of the peripheral areas of the image. These shifts may cause repeated contrast reversals that could create the illusion of motion. The neuroscientist Bevil Conway and his colleagues at Harvard Medical School demonstrated that pairs of static stimuli with different contrast levels can generate motion signals in visual cortex neurons. This phenomenon, in combination with eye movements, may explain the perception of illusory motion in many static patterns, including the *Enigma* Illusion.

THE ROTATING-TILTED-LINES ILLUSION

T his illusion, developed by the vision scientists Simone Gori and Kai Hamburger, is a variation on *Enigma*. To experience the illusion, move your head forward and backward as you fixate in the central area (or, alternatively, hold your head still and move the page). As you approach the image, notice that the radial lines appear to rotate counterclockwise. As you move away from the image, the lines appear to rotate clockwise. Vision scientists have shown that illusory motion activates brain areas that are also activated by real motion. This could help explain why our perception of illusory motion is qualitatively similar to our perception of real motion.

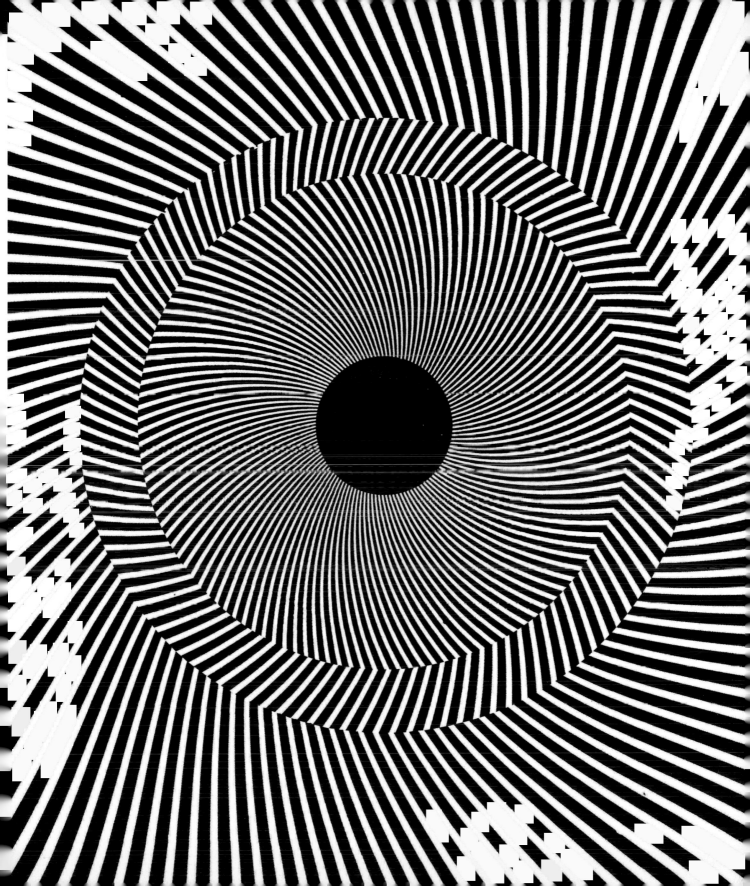

PULSATING HEART

BY GIANNI SARCONE, COURTNEY SMITH, AND MARIE-JO WAEBER

ARCHIMEDES LABORATORY PROJECT, ITALY

2014 FINALIST

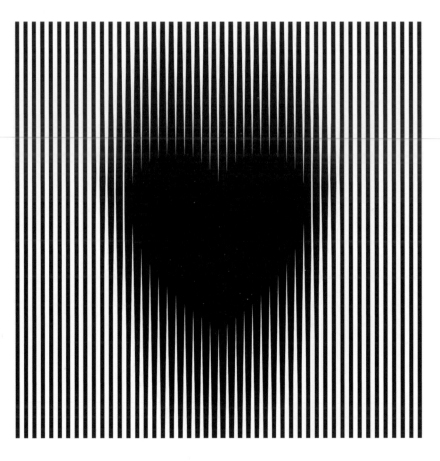

This Op Art–inspired illusion produces the sensation of expanding motion from a completely stationary image. Static repetitive patterns with just the right mix of contrasts trick our visual system's motion-sensitive neurons into signaling movement. Here the parallel arrangement of opposing needle-shaped red and white lines makes us perceive an ever-expanding heart. Any other outline delimited in a similar fashion would also appear to pulsate and swell.

THE BLURRY HEART ILLUSION

BY KOHSKE TAKAHASHI, RYOSUKE NIIMI, AND KATSUMI WATANABE

UNIVERSITY OF TOKYO, JAPAN

2010 FINALIST

The Blurry Heart Illusion is simple yet powerful. Shifting your gaze from one cross to the next makes the blurry heart wobble while the heart with sharp contours remains stationary. This illusion works because the blurred edges—when viewed through your peripheral vision—activate motion-detecting neurons as you move your eyes around on the page. Placing a red heart on a blue background may enhance the effect due to the high color contrast between red and blue.

THE
ROTATING SNAKES
ILLUSION

BY AKIYOSHI KITAOKA

RITSUMEIKAN UNIVERSITY, JAPAN

2005 FINALIST

This illusion is a magnificent example of how we perceive illusory motion from a stationary image. The "snakes" in the pattern appear to rotate as you move your eyes around the figure. In reality, nothing is moving other than your eyes!

If you hold your gaze steadily on one of the "snake" centers, the motion will slow down or even stop. Our research, conducted in collaboration with Jorge Otero-Millan, revealed that the jerky eye motions—such as microsaccades, larger saccades, and even blinks—that people make when looking at an image are among the key elements that produce illusions such as Kitaoka's Rotating Snakes.

Alex Fraser and Kimerly J. Wilcox discovered this type of illusory motion effect in 1979, when they developed an image showing repetitive spiral arrangements of luminance gradients that appeared to move. Fraser and Wilcox's illusion was not nearly as effective as Kitaoka's illusion, but it did spawn a number of related effects that eventually led to the Rotating Snakes. This family of perceptual phenomena is characterized by the periodic placement of colored or grayscale patches of particular brightnesses.

In 2005, Bevil Conway and his colleagues showed that Kitaoka's illusory layout drives the responses of motion-sensitive neurons in the visual cortex, providing a neural basis for why most people (but not all) perceive motion in the image: we see the snakes rotate because our visual neurons respond as if the snakes were actually in motion.

Why doesn't this illusion work for everyone? In a 2009 study, Jutta Billino, Kai Hamburger, and Karl Gegenfurtner, of the Justus Liebig University in Giessen, Germany, tested 139 subjects—old and young—with a battery of illusions involving motion, including the Rotating Snakes pattern. They found that older people perceived less illusory rotation than younger sub-

jects, not only in the Rotating Snakes Illusion, but also in the Rotating-Tilted-Lines Illusion, depicted earlier in this chapter.

But the Pinna Illusion, pictured below, works for most observers irrespective of age. As you move your head (or the image) forward and back while you look at the central dot, you will see the inner and outer rings rotate in opposite directions. So whatever causes these various percepts to change with age, it cannot be as simple as a failure to perceive illusory motion. These findings will, we hope, lead to future research and a more nuanced understanding of the mechanisms underlying motion perception, as well as the specific effects of aging on different brain circuits.

FLOATING STAR

BY JOSEPH HAUTMAN / KAIA NAO

2012 FINALIST

This five-pointed star is static, but many observers experience the powerful illusion that it is rotating clockwise. Created by the artist Joseph Hautman, who moonlights as a graphic designer under the pseudonym "Kaia Nao," it is a variation on Kitaoka's Rotating Snakes Illusion. Hautman determined that an irregular pattern, unlike the geometric one Kitaoka used, was particularly effective for achieving illusory motion. Here the dark blue jigsaw pieces have white and black borders against a lightly colored background. As you look around the image, your eye movements stimulate motion-sensitive neurons. These neurons signal motion by virtue of the shifting lightness and darkness boundaries that indicate an object's contour as it moves through space. Carefully arranged transitions between white, light-colored, black, and dark-colored regions fool the neurons into responding as if they were seeing continual motion in the same direction, rather than stationary edges.

IMPOSSIBLE ILLUSIONS

In an impossible image, seemingly real objects—or parts of objects—form geometric relations that physically cannot happen. The Dutch artist M. C. Escher, for instance, depicted reversible staircases and perpetually flowing streams. The mathematical physicist Roger Penrose drew his famous impossible triangle, and the visual scientist Dejan Todorović created a golden arch that won him third prize in the 2005 Best Illusion of the Year Contest.

The impossible triangle, also called the Penrose Triangle or the Tribar, was actually first created by the Swedish artist Oscar Reutersvärd in 1934. Twenty years later, Penrose attended a lecture by M. C. Escher and, inspired by what he heard, independently rediscovered the Impossible Triangle. Penrose at the time was unfamiliar with the work of Reutersvärd, Giovanni Piranesi, and other previous discoverers of this confounding shape. He drew the illusion in its now most familiar form and in 1958 published his observations in the *British Journal of Psychology*, in an article co-authored with his father, Lionel. In 1961, the Penroses sent a copy of the article to Escher, who incorporated the effect into *Waterfall*, one of his most famous lithographs.

The etchings of water rolling uphill in Escher's *Waterfall* illustrate the artist's remarkable intuition that human perception assembles the whole of an image out of a multitude of little parts. Neuroscientific research has proved Escher right: we now know that the visual system puts together the global perception of a scene from many local relations among object features. As a result, tiny mistakes that are too small to detect locally (and that occur in the real world rarely, if ever) can add up across space to become major mistakes at the global level, and— *voilà!*—you have an impossible image.

Impossible images challenge our hard-earned perception that the world around us follows certain inviolable rules. They also reveal that, because our brains construct the feeling of an overall item by sewing together multiple local features, we don't mind that the global picture is impossible, as long as its local characteristics follow the rules of nature.

Some of our contest competitors, such as Kokichi Sugihara, have gone a step further and created real-world 3-D objects that nonetheless appear to be impossible. Unlike Renaissance or classical sculptures, such as Michelangelo's *Pietà* or the Winged Victory of Samothrace, which can be perceived by either sight or touch, impossible sculptures can be interpreted (or misinterpreted, as the case may be) only by the visual mind.

IMPOSSIBLE MOTION: MAGNETIC SLOPES

BY KOKICHI SUGIHARA

MEIJI INSTITUTE FOR ADVANCED STUDY OF MATHEMATICAL SCIENCES, JAPAN

2010 FIRST PRIZE

A Japanese miner climbs onto the stage with his helmet light bobbing and a pickax slung over his shoulder. He swings the pick a few times and then kneels to inspect something. He digs at some loose rubble with his hands. Suddenly his face lights up and he turns to the audience with newfound riches held forward. "I have discovered a new supermagnet that attracts wood," he announces. Okaaaay . . . A video begins playing, and the audience sees four wooden balls rolling uphill, in open defiance of the laws of gravity. Are they being pulled by a magnet? Not really. The "miner" is the mathematical engineer Kokichi Sugihara, and his magnetlike illusion was the winner of the 2010 Best Illusion of the Year Contest. The trick is revealed when we see Sugihara's slopes from a different vantage point: the wood balls are actually rolling down the ramps, not up. The slopes are cleverly designed to produce an illusion of antigravity from a specific point of view. Sugihara's invention exemplifies several of the most popular themes in illusion research and creation today. It uses a trick of perspective that produces perceptual ambiguity. There is more than one way to perceive the "magnetic" slopes, but our visual system makes us prefer one interpretation, based on how we expect physical reality to work. Impossible illusions are a way to fool the brain into revealing its default expectations about the world.

"We are surrounded by many industrial products that are made with right angles, such as desks, boxes, and buildings," Sugihara explained. When confronted with an image that allows for multiple interpretations, we choose the version that allows us to see rectangular solids. In Sugihara's illusion, none of the columns that support the ramps are vertical, but we interpret them all as perfectly straight. We also perceive, incorrectly, that the center column is the tallest.

Sugihara discovered this illusion by using a computer program designed to read 3-D line

drawings, such as architectural blueprints. He tested the program by feeding it images of impossible objects drawn in the style of Escher. He expected the program to respond with an error message; instead, the software interpreted some of the images as peculiar 3-D solids. Sugihara assumed he had a bug in his code, but soon realized that the software was recognizing objects that only seemed impossible from a certain point of view. Delighted, he set out to construct some of these objects, and later added an element of motion to enhance the illusion. To appreciate the magic fully, you can see the balls moving at the Best Illusion of the Year Contest website.

ELUSIVE ARCH

BY DEJAN TODOROVIĆ

UNIVERSITY OF BELGRADE, SERBIA

2005 FINALIST

Is this an image of three shiny oval tubes? Or is it three pairs of alternating ridges and grooves?

The left side of the figure appears to be three tubes, but the right side looks like a corrugated surface. This illusion occurs because our brain interprets the bright streaks on the figure's surface as either highlights at the peaks and troughs of the tubes or as inflections between the grooves. Determining the direction of the illumination is difficult: it depends on whether we consider the light as falling on a receding or an expanding surface. Trying to determine where the image switches from tubes to grooves is maddening. In fact, there is no transition region: the whole image is both "tubes" and "grooves," but our brain can only settle on one or the other interpretation at a time. This seemingly simple task short-circuits our neural mechanisms for determining an object's shape.

IMPOSSIBLE ILLUSORY TRIANGLE

BY CHRISTOPHER TYLER

SMITH-KETTLEWELL EYE RESEARCH INSTITUTE, U.S.A.

2011 FINALIST

Christopher Tyler of the Smith-Kettlewell Institute in San Francisco invented the auto-stereogram, a type of random dot pattern that allows many people to perceive a 2-D image as if it were in 3-D. Autostereograms are the basis for the famous Magic Eye books that were all the rage in the 1990s. In true academic fashion, of course, Tyler never made a cent off them. (Although he discovered a method for creating autostereograms, he did not patent it.) At the 2011 contest, Tyler began his presentation by showing the Penrose Triangle, the quintessential impossible object introduced at the beginning of this chapter. Tyler also displayed another famous triangle, the one named for the Italian psychologist Gaetano Kanizsa that we also described earlier. The Kanizsa Triangle shows that the brain can create entire objects by filling in missing information. Tyler wondered whether he could integrate the two perceptual traditions. When he laid the outline and inner crossbars of the Penrose Triangle over the three incomplete balls denoting the Kanizsa Triangle, he discovered something remarkable: the brain will fill in the shapes not only of simple figures, but of impossible ones, too. Tyler's illusion confirms the idea, mentioned in this chapter's introduction, that our brains construct the feeling of a global 3-D percept by sewing together multiple local percepts. As long as the relations among local features follow nature's rules, our brains do not seem to mind that the global percept is impossible, or that the local structures contain only the sparsest information.

AND THE WINNER IS . . .

or many years, the Italian sculptor Guido Moretti donated copies of his *Three-Bar Cube* and other impossible sculptures as trophies for the Best Illusion of the Year Contest. Depending on your vantage point, the *Three-Bar Cube* appears to be a Necker cube (the classical illusion named after the Swiss crystallographer Louis Albert Necker), an unspecified solid structure, or an impossible triangle. This specific vantage point is known to scientists as the accidental view, but there is nothing accidental about it. For the observer to perceive each particular shape, the view must be carefully staged and choreographed.

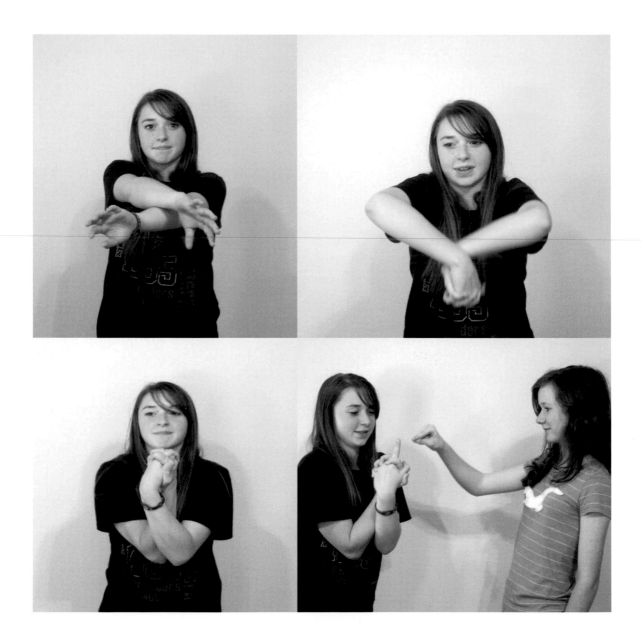

9

MULTISENSORY AND NONVISUAL ILLUSIONS

Our nervous system gathers all different kinds of sensory information from the outside world and from our own bodies, but visual inputs take up the most processing power. Though the experience of viewing an object may seem simple and effortless, our brain's cortex alone dedicates more than two dozen areas to analyzing, filling in, transforming, and relaying visual inputs. Such extraordinary allocation of neural muscle can make us lose sight—pun intended—of the fact that our experience of the world is fundamentally multisensory. Scientists and philosophers since Aristotle have pondered how the brain is able to integrate different kinds of sensory information into a unified perception. In the initial stages of neural processing, the inputs from the different senses (sight, touch, hearing, taste, and smell) are kept separate, in different processing streams that lead to different cortical areas of the brain (the visual cortex, the somatosensory cortex, the auditory cortex, and others). These areas are physically distinct and largely disconnected from one another. Even within a given sensory modality, such as in the visual system, specific cortical areas and populations of neurons deal with particular features, such as motion, color, texture, and faces. How the brain puts together different kinds of information so that when we encounter a puppy we can see it wagging its tail, feel its fur under our hands as we pet it, and hear its excited bark all at once, as a single perception, is a neuroscientific mystery known as "the binding problem." Some of the illusions in this chapter illustrate the paradoxical features of our nonvisual perception. Others demonstrate the unusual ways in which our brain integrates (or sometimes fails to integrate) the information arriving from our different senses.

THE DISAPPEARING HAND TRICK

BY ROGER NEWPORT, HELEN GILPIN, AND CATHERINE PRESTON

UNIVERSITY OF NOTTINGHAM, U.K.

2012 FIRST PRIZE

A trusting young woman puts her hands in a box with a transparent top. She is participating in a science experiment, but this one has the aura of a magic show. The researchers ask her to hold her hands steady between two vertical blue lines. She does so, watching her hands carefully. They do not appear to move, nor does she feel as if they are moving. The investigators flick a switch and the right side of the box darkens, obscuring her right hand. They ask her to reach across with her left hand and touch her now invisible right one. She complies—but her eyes widen with alarm. All she feels is empty space. "Where's my hand gone?" she asks anxiously. Then, suddenly, she explodes with laughter. Still, just to be sure, she pulls both her hands from the box to check that they are still there—they are.

This scene, captured on video, helped the inventors of the mirage multisensory illusion box win first prize at the 2012 Best Illusion of the Year Contest. Like many illusions, this one was discovered by accident. Three psychologists created the box to study how the brain integrates visual input, tactile information, and proprioception, or bodily sensations that tell us about the position of our limbs in space. One day, Roger Newport, one of the psychologists, was trying to fix a misalignment in the box. He discovered that his right hand was in the wrong place and his left one was out of sight. "I tried to touch my left hand with my right and missed it. I was so surprised I decided to see whether I could re-create the feeling experimentally," he says. Equipped with a camera, a mirror, and a monitor, the box created the illusion that the woman was looking at her own hands when in fact she was seeing a video re-creation of them. The hand images, manipulated by computer software, moved slowly inward. To compensate, the woman moved her hands outward—although it all happened so gradually that she did not notice. In less than a minute, the space between her hands became much greater than she real-

1

2

3

4

5

ized. Then she was surprised when she tried to touch her hand and discovered that it was not where she thought it was.

In everyday experience, sensations such as sight, touch, and proprioception work together to inform us about the location of our various body parts. Think of how jerky a baby's early movements are, and how unsteady she is as she learns to walk. She dynamically adjusts and re-adjusts virtually every muscle in her body as she struggles to remain upright. You do the same, even when sitting still, just more smoothly and without conscious oversight. The mirage box created by Newport and his colleagues shows that the brain is easily confused when our touch and bodily sensations are dissociated from the visual input. For a demonstration, visit the Best Illusion of the Year Contest website. An amusing video showing the best reactions from partic-ipants in the Disappearing Hand Trick is available on YouTube.

THE KNOBBY SPHERE ILLUSION

BY PETER TSE

DARTMOUTH COLLEGE, U.S.A.

2013 FINALIST

Illusions are not only perceived by our visual system. They can also be created through the sense of touch, as noticed by the cognitive neuroscientist Peter Tse of Dartmouth College. Try it yourself. Get a pencil and a small, round, hard sphere, such as a ball bearing or a marble. First, squeeze the sides of the pencil very tightly between your thumb and forefinger for sixty seconds or so, until you make deep indentations in your thumb and forefinger pads. Now feel the ball bearing at the location of the indentations by rolling it around. The ball no longer seems round but instead feels as if it has rounded corners—as if the ball were hexagonal in cross section, just like the pencil. When you squeeze the pencil, the array of touch receptors in your skin takes on its shape. Your brain assumes that the skin where your receptors are located is smooth and round, and it misattributes these perceived edges as belonging to the ball.

FISHBONE ILLUSION

BY MASASHI NAKATANI

KEIO UNIVERSITY, JAPAN

2011 FINALIST

his tactile illusion will give you a very fishy feeling. At the 2011 Best Illusion of the Year Contest, the scientist Masashi Nakatani, who studies haptic perception (i.e., the sense of touch), showed up dressed in spearfishing attire and passed out business cards embossed with the shape of a stylized fish. With the flourish of a magician, Nakatani approached the emcee, the vision scientist Peter Thompson, onstage and told him, "Rub your finger up and down the spine. Up and down the spine. You feel a groove there? But . . . there . . . is . . . none!" Thompson rubbed the fish's spine as instructed. "How do you feel?" Nakatani asked.

"I feel dirty for feeling up this fish," Thompson deadpanned. "But I do feel a groove here."

Nakatani was intrigued by the possibility that the brain might experience tactile as well as visual illusions. He thought he could create a texture that was not a circle but would feel like one. The fishbone pattern (without a head or tail) was one of many botched attempts. Disappointed, Nakatani took the sample to a senior colleague, Susumu Tachi, and described his failure. Tachi agreed that the texture did not feel like a circle, but he noticed a central groove where there was none. He encouraged Nakatani to change his dissertation project to study the fishbone illusion full-time. By testing a variety of configurations and textures, Nakatani and his colleagues determined that the illusion arises from how tactile receptors in your skin compare smooth and rough textures. Even though the spine and ribs of the fish are embossed exactly the same way, the ribs feel rougher to the touch because they are discontinuous; the spine is continuous from beginning to end, so it feels smoother than the ribs. Your brain interprets the smooth spine to be lower than the rough ribs of the fish—and you're hooked.

DISAPPEARING SMOKE— DISAPPEARING PLEASURE!

BY SIDNEY PRATT, MARTHA SANCHEZ, AND KARLA ROVIRA

SIN HUMO, COSTA RICA

2013 FINALIST

The clinical psychologists Sidney Pratt, Martha Sanchez, and Karla Rovira are members of Sin Humo, an anti-smoking treatment program in Costa Rica whose name translates to "Without Smoke." Their illusion was inspired by a relaxation technique in which a person closes his or her eyes while smoking. This small act, surprisingly, decreases the enjoyment typically felt from a cigarette—and less enjoyment, they reasoned, would lead to weaker addiction.

Pratt's team wondered, was it relaxation per se that reduced the patients' gratification? Or was it primarily the fact that the patients' eyes were closed, preventing them from seeing the burning cigarette? To find out, they simply asked the patients to smoke while blindfolded, and learned that the blindfold did in fact account for the reduction in the pleasure from smoking.

The contest judges classified this demonstration as an illusion because the smokers' perceptions did not match the biochemical reality of smoking. In other words, we assume that the amount of pleasure derived from a cigarette should be based on the amount of nicotine it delivers. That amount, of course, is the same with or without the blindfold, and so the patients' brains were effectively tricked.

In light of these findings, the researchers reasoned that seeing the smoke from a cigarette might strengthen nicotine addiction because the smoke is associated with past experiences of feeling satisfied. Their discovery also suggests that it's very rare for any experience to affect a single sensory modality. All of our senses may be engaged in powerful, unexpected ways when we interact with the world around us. The blindfolding technique is now the cornerstone of the team's anti-smoking treatment plan.

ATTENTION ILLUSIONS

or a neuroscientist, the trouble with cocktail parties is not that there are cocktails or that it's a party (many neuroscientists love both). Instead, what we call "the cocktail party problem" is the mystery of how anyone can have a conversation at a cocktail party at all.

Consider a typical scene: You have a dozen or more lubricated and temporarily uninhibited adults telling loud, improbable stories at increasing volumes. Interlocutors guffaw and slap backs. Given the decibel level, it is a minor neural miracle that any of these revelers can hear and parse even one word emitted by their friends.

The alcohol does not help to solve this complicated problem, but it is not the main source of confusion. The issue is that there is simply too much going on at once. How can our brains filter out the noise and focus on specific information?

This problem is a central one for neuroscientists—and not just during cocktail parties. The entire world we live in is quite literally too much to take in. Yet the brain does gather all of this information somehow and sorts it in real time, usually seamlessly and correctly. The sounds and sights around you include at least as much noise as signal, but the conversation or object that interests you remains in clear focus—at least this is how you perceive it.

How does the brain accomplish this feat? One critical component is that our neural circuits actively suppress anything that is not task-relevant. Our brains pick their battles. They stomp out irrelevant information so that the good stuff has a better chance of rising to awareness. This process, colloquially called "attention," is how the brain sorts the wheat from the chaff. You pick and choose what you want to see and hear, and your attention system filters out the noise—which is everything else.

In collaboration with the laboratories of the neuroscientists Jose-Manuel Alonso of the

SUNY College of Optometry and Harvey Swadlow of the University of Connecticut, we discovered some of the initial circuits that mediate attention in the primary visual cortex of the brain. To do so, we observed neurons in this area, some of which encourage activity in other brain cells, so-called excitatory neurons, and others that tamp down activity, known as inhibitory neurons. We found that when someone attends to a specific location, the inhibitory neurons take action, suppressing responses to other visual locations. In short, the brain depends on inhibitory neurons to enable focus.

Even more interesting was our finding that the harder you concentrate, the greater the suppression. One fundamental role of cognition is to select what your brain goes on to process. It does that, at least in part, by blocking irrelevant information.

But that is not attention's only role. As the neural activity associated with attention travels down throughout the visual system's circuits, it can also affect how we perceive and interpret the color and brightness of objects. The illusions in this chapter illustrate some of the numerous perceptual consequences of our brain's attentional mechanisms.

James Randi (aka the Amaz!ng Randi), on the left, performed at the 2010 Best Illusion of the Year Contest. Dan Simons, on the right, is posing in his signature gorilla costume.

THE MONKEY-BUSINESS ILLUSION

BY DANIEL SIMONS

UNIVERSITY OF ILLINOIS, U.S.A.

2010 FINALIST

In a famous experiment done in 1999, Daniel Simons and Christopher Chabris, both then at Harvard University, asked subjects to watch two groups of people dribbling and passing a basketball among themselves. Three players wore white shirts; three wore black. The watchers were asked to count the number of passes by the players in white shirts. About halfway through the exercise, a gorilla—that is, a person in a gorilla suit—walked into the ball-passing scene, beat its chest while facing the camera, then walked out.

Simons and Chabris were shocked to discover that about half of the people counting passes failed to notice the gorilla. Their spectacular demonstration became an instant classic, spreading to conferences, university courses, and textbooks. It is an excellent example of inattentional blindness, a phenomenon in which the brain ignores information that is not relevant to its current task. The gorilla illusion is so well-known that Simons decided to create a variation for the 2010 illusion contest. He appeared at the gala dressed as a gorilla, flinging bananas to the audience before he took the stage. "You are all good vision scientists," he said. "You know that when people are passing basketballs you should be looking for gorillas." The audience roared with laughter at the inside joke.

People can only experience the invisible gorilla illusion once. After you know to look for a gorilla, you'll never miss it again. Does knowledge of the impending occurrence of unexpected events help you detect other unexpected events? Simons's latest demonstration, called the Monkey-Business Illusion, shows that the answer is no. People who know to look for a gorilla are of course more likely to spot the gorilla. But these same viewers will fail to notice other unanticipated happenings—and are even more likely to do so than viewers who are unfamiliar with the illusion. Again, the harder you pay attention during a task, the more powerfully your

visual system suppresses distracting information. The more you watch out for the gorilla that you expect to appear, the more you will miss other changes that are unpredicted.

As the gorilla-suited Simons explained, there are several changes that most people overlook when they watch the Monkey-Business Illusion: the background of the image changes color from red to gold, and one of the three black-shirted players leaves the game by discreetly backing out of the scene. Simons had one final surprise: "Did any of you spot a pirate?" Simons asked the audience. The spectators groaned, rolled their eyes, and shook their heads at yet another impossible oversight. But the undetected pirate was not in the video. Simons pointed to stage right, where a spotlight beamed down on a pirate, previously unnoticed yet completely out in the open for all to see, holding a sword to the neck of the contest's technical director (Steve). The illusion had spilled out of the video onto the stage!

Still frames from the illusion show (top left) the scene before the gorilla appears, (top right) the gorilla entering and one of the players in black backing out of the scene, (middle left) the gorilla thumping its chest, (middle right) the gorilla exiting, and (bottom) the scene after the gorilla has left. The color of the curtain has changed, and now only two black-shirted players remain.

ATTENTION TO BRIGHTNESS

BY PETER TSE

DARTMOUTH COLLEGE, U.S.A.

2005 FINALIST

At the 2005 illusion contest, Peter Tse presented one of the simplest but most important illusions ever discovered: three semitransparent overlapping circles. Look carefully at the blue dot in the center of the three intersecting disks while directing your attention to each of the three disks in turn. If you are paying attention to the bottom disk, for example, you will see that it looks brighter than the other two disks. The same is true when you turn your attention to one of the other disks. Before Tse discovered this illusion, neurophysiologists believed that people cast a spotlight of attention on a specific location, leaving the rest of the world in relative darkness. Tse showed that the spotlight concept was not just a useful metaphor. When we direct our attention to a specific object or area of an image, it appears more salient than the regions we don't attend to. Even the apparent contrast of the focused area is higher than the rest of the picture! The neural mechanisms responsible for this phenomenon are the same that prevent you from seeing the gorilla when counting basketball passes in Simons and Chabris's original demonstration. Our brain actively suppresses the parts of a scene that we don't pay attention to, so that the regions that we do focus on appear more prominent in comparison.

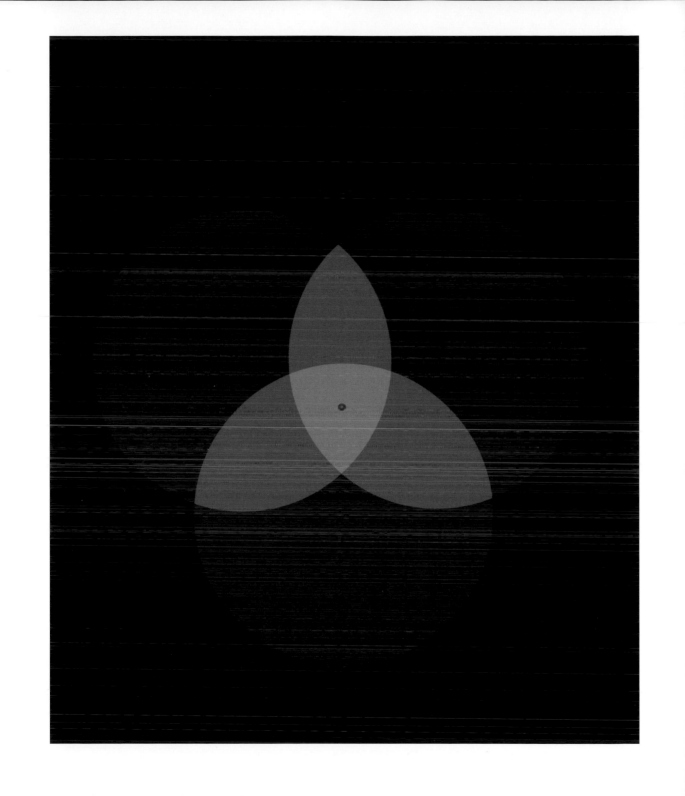

ATTENTION TO COLOR

BY PETER TSE

DARTMOUTH COLLEGE, U.S.A.

2012 FINALIST

even years after creating the Attention to Brightness Illusion, Tse discovered a related color effect. Three colored disks overlap in the center like a Venn diagram. If you fix your gaze on the central intersection and focus on one disk, that entire disk will appear to become uniform in color—for instance, the disk with the blue outline and outer region will appear uniformly blue. It will also seem to be floating transparently above the other disks, even though the colors are mixed in some regions—and the center of the composition is actually gray!

This illusion demonstrates the brain's remarkable ability to see different things in the same scene, depending on your focus. For example, when you look at a pond, you may see clouds reflected on the surface, but with a subtle shift of attention you can instead find yourself observing the stones at the bottom. In the same way, as you shift your attention to a specific disk in Tse's drawing, your brain suppresses the other disks and enhances the one you are focusing on. One reason our attentional systems may have evolved to work the way they do is to concentrate our limited neural resources—so we can make the best of them—on specific tasks. We simply don't have the neural machinery to grasp all the sensory information around us in any depth, so our brains must pick and choose what to prioritize from one moment to the next. In that sense, our attentional focus is not a neural shortcoming but an enhancement. Human accomplishments such as science, technology, and even art would not exist but for people who were—and are— able to concentrate on minute areas of interest for extended periods of time, while taking no notice of most of the world around them.

ATTENTION TO AFTERIMAGES

BY PETER TSE

DARTMOUTH COLLEGE, U.S.A.

2010 FINALIST

n 2010, Tse showed that attention can also affect the perception of afterimages, the illusory visuals that linger after you look at a bright light or stare at a picture for a while. Focus your gaze on the center of the checkered pattern for one full minute, then shift your eyes to the empty rectangles at the right. You will see a colorful afterimage filling in the formerly empty frames. Now try paying attention to the vertical rectangle, and you will see an afterimage that matches it. Pay attention to the horizontal rectangle and you will see a different afterimage. You can go back and forth between the two afterimages simply by shifting your attention from one rectangle to the other.

Afterimages help scientists understand how neurons in our eyes and brains temporarily cease responding to an unchanging stimulus. The ghostly visions appear during the brief period before the neurons reset to their normal, responsive state. Neuroscientists know that retinal neurons play a role in the perception of afterimages, but it has been difficult to demonstrate the importance of neural processing at higher levels in the visual pathway from the eye to the brain. Tse's illusion proves that afterimages can be strongly modulated by cognitive processes such as attention.

APPENDIX: DYNAMIC ILLUSIONS

Twenty-first-century illusion creators continue to produce printable illusions using still photographs or even just a few lines on paper, but computer and video technologies have made it possible to create increasingly complex moving-picture illusions. This appendix is dedicated to illusions that are best seen on the screen. To view them, visit the Best Illusion of the Year Contest website, http://illusionoftheyear.com.

GROUPING BY CONTRAST
By Erica Dixon, Arthur G. Shapiro, and Kai Hamburger • American University, U.S.A., and University of Giessen, Germany • 2011 Second Prize
This illusion expands on what researchers call the "Gestalt laws," formulated by German psychologists in the 1920s to describe human perception. It shows that your brain tends to group objects together based on their absolute contrast—here your brain groups blinking dots in different ways, depending on their background.

ILLUSORY GLOSS
By Maarten Wijntjes and Sylvia Pont • Delft University of Technology, The Netherlands • 2010 Finalist
This illusion shows that an object's surface can look either matte or glossy, depending on the direction of illumination.

SILENCING COLOR
By Jordan Suchow and George Alvarez • Harvard University, U.S.A. • 2011 First Prize
Suchow discovered this illusion when he dropped his laptop and noticed that a scintillating doughnut on the screen appeared to stop moving while the laptop was in midair—a phenomenon called "silencing," by which our brain suppresses one kind of perception when confronted with another. Here the dots rapidly switch color but appear to stop when the doughnut begins rotating, even though they continue to change the entire time!

CONTRAST COLOR INDUCED BY UNCONSCIOUS SURROUND
By Haruaki Fukuda and Kazuhiro Ueda • University of Tokyo, Japan • 2009 Finalist
A simple children's top can be a powerful visual neuroscience tool. Here the colored wedges blur into gray when the disk spins—but the black lines take on the opposite color of the wedges in which they are embedded. This color induction happens before your perception fuses the surrounding colors.

WHEN PRETTY FACES TURN UGLY
By Jason Tangen, Sean Murphy, and Matthew Thompson • University of Queensland, Australia • 2012 Finalist
Tangen and his colleagues caused perfectly normal-looking faces to appear grotesque by aligning them with other faces and displaying each image briefly. The illusion works because your visual system processes each face not as an isolated entity but in comparison with the faces that precede it.

ROTATING BY SCALING
By Attila Farkas and Alen Hajnal • University of Southern Mississippi, U.S.A. • 2013 Finalist
Rigid objects—or those that we expect to be rigid—appear to rotate when they are stretched (scaled) asymmetrically. In a dramatic example, created by the psychologists Attila Farkas and Alen Hajnal, a stationary computer-generated head appears to turn around a vertical axis when one half of the head is stretched and the other compressed.

COUNTERINTUITIVE ILLUSORY CONTOURS
By Barton Anderson • University of Sydney, Australia • 2010 Second Prize
A diamond shape alternately expands and shrinks as disks and dots move back and forth—but the diamond is entirely constructed by your visual system. Anderson's illusion illustrates the brain's ability to fill in much of the missing information in a scene, often creating complicated percepts from very simple constituents.

MUTUALLY INTERFERING SHAPES
By Maarten Wijntjes, Robert Volcic, and Tomas Knapen • Utrecht University, The Netherlands • 2008 Finalist
This illusion shows that the perceived trajectory of a dot depends on its position relative to other objects in the world. While an outer dot travels around a circle, an inner dot moves along the straight sides of a square—and yet it appears to follow a trajectory made up of concave curves.

TILT ILLUSION
By Siddharth Jain • U.S.A. • 2009 Finalist
A horizontally moving dot appears to follow a tilted trajectory, when it only shifts down a row. The effect may result from the phenomenon called "persistence of vision," presented by Peter Mark Roget (who also wrote the famous thesaurus) to the Royal Society of London in 1824 as the ability of the retina to retain an image of an object for a twentieth to a fifth of a second after its disappearance—an illusion that is crucial to animation.

THREE-FOLD CUBES: AN OBJECT WITH THREE DIFFERENT FORM INTERPRETATIONS
By Guy Wallis and David Lloyd • University of Queensland, Australia • 2013 Finalist
The same object can look like two cubes, a single cube with a cube-shaped bite taken out of it, or a concave surface illuminated from below. The brain cannot decide, because each interpretation is equally correct. As a result, our perception cycles endlessly through the possibilities.

THE BAR-CROSS-ELLIPSE ILLUSION
By Gideon Caplovitz and Peter Tse • Dartmouth College, U.S.A. • 2006 Third Prize
Gideon Caplovitz and Peter Tse's four-way illusion pushes the ambiguity envelope even further. Here the same unique moving object can be seen as a cross-shaped figure morphing nonrigidly in size and shape, an ellipse rigidly rotating behind four square occluders, two independent perpendicular bars rigidly oscillating in depth, or a stationary cross viewed through an elliptical aperture that is rotating rigidly.

TWO SINUSOIDS: SIX PERCEPTIONS IN ONE
By Jan Kremláček • Charles University in Prague, Czech Republic • 2010 Third Prize

Caplovitz and Tse's 2006 record of a tetra-ambiguous illusion stood until Kremláček created his six-in-one sinusoids in 2010. Kremláček's illusion combines stationary and moving sinusoids in an animation that can be perceived in any of six different ways, including a rotating double helix, a waving ribbon, or a set of dots bouncing up and down.

ROLLING EYES ON A HOLLOW MASK
By Thomas Papathomas • Rutgers University, U.S.A. • 2008 Third Prize

This hollow mask is concave, but because your brain assumes that all faces are convex, that's how it appears. Whereas a convex face would look in only one direction, a hollow face seems to look forward when the viewer is directly ahead, but at an angle when the viewer moves sideways. The vision researcher Thomas Papathomas attached three-dimensional eyeballs and a nose ring to a hollow mask; when the mask rotates, the eyeballs and nose ring appear to rotate in the opposite direction.

EXORCIST ILLUSION
By Thomas Papathomas, Tom Grace Sr., Marcel de Heer, and Robert Bunkin • Rutgers University, U.S.A. • 2012 Finalist

Papathomas and his colleagues also created a "hollow body" illusion, with a critical twist: they paired a hollow mask with a nonhollow torso, and vice versa. The sculptures have no moving parts, but when the head-torso composites are rotated, "the effect is a flexible, twisting neck out of a 3-D rigid [body], like in *The Exorcist*," Papathomas says. This illusion reveals some of the biases the brain uses to interpret the orientation of faces and bodies. For example, your brain assumes that people's faces and bodies are lit from above, by the sun. So when you view a hollow mask or body and the lighting orientation appears reversed, so does the rotational direction.

STEREO ROTATION STANDSTILL
By Max Dürsteler • University Hospital Zurich, Switzerland • 2008 Finalist

The wagon wheel shape in this illusion exists solely within stereoscopic space. When it rotates at an angular velocity greater than thirty degrees per second, the turning stutters and skips, and sometimes completely stops, even though it actually rotates smoothly.

TRANSLATION WITH A TWIST
By Jun Ono, Akiyasu Tomoeda, and Kokichi Sugihara • Meiji University, JST, CREST, Japan • 2013 First Prize

Ono, Tomoeda, and Sugihara showed that two identical stationary pinwheels appear to spin in opposite directions when a grid moves across them.

TUSI OR NOT TUSI
By Arthur G. Shapiro and Alex Rose-Henig • American University, U.S.A. • 2013 Second Prize

This illusion takes advantage of the fact that we group individual moving objects into global structures depending on the statistical relation among those objects. Depending on where you focus your attention, you'll see different kinds of motion.

DANCING DIAMONDS
By Michael Pickard and Alessandro Soranzo • University of Sunderland and Sheffield Hallam University, U.K. • 2013 Finalist

Nothing actually moves in this illusion, though your brain begs to differ. The edges of the diamonds do not move,

or even change—it's the diamonds' insides that cycle between dark and light—but there is a distinct sense of movement nevertheless. Further, the entire collection of diamonds appears to move as a whole—like objects drawn on an elastic surface that is blowing in the wind—rather than as individual parts.

PIGEON-NECK ILLUSION
By Jun Ono, Akiyasu Tomoeda, and Kokichi Sugihara • Meiji University, JST, CREST, Japan • 2014 Finalist
An object progressing at constant speed in front of a vertical grid of stripes appears to shift backward and forward. The motion is similar to the action of a walking pigeon's neck.

HYBRID MOTION
By Arthur G. Shapiro and Oliver Flynn • American University, U.S.A. • 2014 Finalist
Shapiro and Flynn's illusion consists of an array of rectangles that change from yellow to blue to yellow over time. The physical positions of the rectangles never change, but they appear to move in opposite directions, depending on whether the observer is close to the monitor or far from it.

THE WILE E. COYOTE ILLUSION
By Alan Ho and Stuart Anstis • Ambrose University College, Canada; and University of California, San Diego, U.S.A. • 2013 Finalist
Alan Ho noticed that a computer representation of a turning fan blade appeared to spin twice as fast after he doubled its number of blades. Likewise, cartoon animators often draw multiple legs and feet on fast-moving characters, such as Wile E. Coyote, to convey the illusory feeling of speed. Ho and Stuart Anstis showed that increasing the number of orbiting circles around a larger one makes the smaller circles seem to be moving faster, even though their speed remains constant. This illusion has commercial and practical applications for computer games, advertising, and even road safety.

THE LOCH NESS AFTEREFFECT
By Mark Wexler • Université Paris V, France • 2011 Third Prize
This illusion is named for a classic phenomenon known to the ancient Greeks and rediscovered in 1834 by Robert Addams at the Falls of Foyers, the waterfalls that feed Loch Ness in Scotland. Addams noticed that after he stared at the waterfalls for a while, stationary surfaces, such as the rocks and vegetation beside the falling water, appeared to drift upward. In Wexler's illusion, the viewer stares at a red dot surrounded by a rotating ring of dashes. Suddenly the ring jumps in the opposite direction with a rapid rotation, before continuing to turn slowly in the original direction. Wait—the ring is not really jerking backward, but its elements are simply reassorted at random. The resulting illusory motion is more than a hundred times faster than the motion described by Addams.

COLOR WAGON WHEEL
By Arthur G. Shapiro, William Kistler, and Alex Rose-Henig • American University, U.S.A. • 2012 Third Prize
This illusion was inspired by a classic phenomenon known as the Wagon Wheel Illusion, in which nested circular rows of black disks rotate clockwise but appear to do so counterclockwise. Here some of the disks are colored yellow. The result is a novel and striking illusion: a wheel that spins simultaneously in both directions.

THE STEERABLE SPIRAL
By Peter Meilstrup and Michael Shadlen • University of Washington, U.S.A. • 2010 Finalist
Multiple moving spots—special visual objects called Gabor patches—travel in a spiral toward the center of a circle. Each of them contains a small grating that moves opposite to the spot's direction of travel. When presented alone,

each spot moves in a single, clear direction. But when multiple spots are in close proximity to each other, their internal motion confounds the brain's movement-detection circuits, and produces the perception of a false direction. The effect is dramatic when you shift your gaze from the center of the spiral to the edge of the screen: the rotation direction reverses, but only in your mind!

MOTION-ILLUSION BUILDING BLOCKS
By Arthur G. Shapiro and Justin Charles • Bucknell University, U.S.A. • 2005 First Prize

A flashing square surrounded by a two-tone alternating frame results in illusory motion. Shapiro and Charles showed that you can combine illusory building blocks of motion to create countless new movement illusions. It's like illusion Legos of the mind!

TWO-STROKE APPARENT MOTION
By George Mather • Sussex University, U.K. • 2005 Second Prize

This effect alternates two spatially shifted images—with a gray frame between the alternations—to create the illusion of a speeding motorcycle down a country lane. The "jump" between the pictures makes the images appear to move forward, as in a movie.

BACKSCROLL ILLUSION
By Kiyoshi Fujimoto • Kwansei Gakuin University, Japan • 2005 Finalist

An object in the foreground appears to move in one direction, while a flickering grating (or static noise) occupies the background—leading to the perception that the background is moving in the opposite direction to the foreground illusory motion! For example, when an animated cartoon character appears to walk toward the left in the foreground, the flickering background appears to go to the right.

THE WINDMILL ILLUSION
By Baingio Pinna and Massimiliano Dasara • University of Sassari, Italy • 2005 Finalist

The windmill appears to turn, but it is actually stationary. Only the transparency of the middle ring causes your brain to believe that the windmill is moving. As the ring fades in and out of your vision, you are fooled into seeing the windmill turn in *both* directions.

THE FREEZING ROTATION ILLUSION
By Max Dürsteler • University Hospital Zurich, Switzerland • 2006 First Prize

A foreground object's motion appears to vary with the rotation of an image in the background.

GRADIENT-OFFSET INDUCED MOTION
By Po-Jang Hsieh • Dartmouth College, U.S.A. • 2006 Finalist

When square-shaped grayscale luminance gradients disappear—all at once—you see ghostly movement that flows from left to right.

THE OCCLUSION VELOCITY ILLUSION
By Evan Palmer and Philip Kellman • Harvard Medical School and University of California, Los Angeles, U.S.A. • 2006 Finalist

When a moving object suddenly splits in half, masking the motion of one of the halves makes the two parts appear misaligned.

WHERE HAS ALL THE MOTION GONE?

By Arthur G. Shapiro and Emily Knight • Bucknell University, U.S.A. • 2007 Third Prize

If you cycle the background luminance behind a stationary gradient from black to white to black (and repeat), you can see illusory motion within the gradient. This motion illusion is strikingly enhanced when the gradient is blurred.

BOUNCING BRAINS

By Thorsten Hansen, Kai Hamburger, and Karl R. Gegenfurtner • University of Giessen, Germany • 2007 Finalist

Some of the brains in this illusion are lighter than the background, and others are darker. As the background luminance is modulated, the brains rotate and bounce. In certain areas of the image, the adjacent brains move in unison, creating an even greater illusory effect.

PINBALL WIZARD

By Michael Pickard • University of Sunderland, U.K. • 2008 Finalist

A semitransparent screen is positioned over a series of drifting spheres, and semitransparent blobs on the screen take on properties of both the foreground and the background. When the screen is over a drifting sphere, that sphere takes on the blobs as a surface property, making the sphere rotate and roll rather than drift (although there is no rolling motion in the display). Simultaneously, when the blobs are not overlaid on a sphere, they appear as splotches on the background, behind the spheres.

DRIFTING BACKGROUND ILLUSION

By Masaharu Kato • Uppsala University, Sweden • 2007 Finalist

A small pink dot moves back and forth in front of a background of static noise. But when this background noise is dynamic (albeit not moving), the pink dot's motion makes the background appear to drift in the opposite direction.

SWIMMERS AND EELS

By Emily Knight and Arthur G. Shapiro • Bucknell University, U.S.A. • 2007 Finalist

Oval dots ("swimmers") stand in the foreground of a multicolored grating. The swimmers bob up and down with the grating. Remove the grating and replace it with a uniform background, and the bobbing disappears.

STEEL MAGNOLIAS AND BREEZE IN THE TREES

By Michael Pickard • University of Sunderland, U.K. • 2007 Finalist

Leaves and flower petals blow in the breeze, though the whole image is actually stationary. The coloring of individual petals and leaves merely cycles from light to dark, whereas the two opposite edges of each petal or leaf remain dark or light.

PERPETUAL COLLISIONS

By Arthur G. Shapiro and Emily Knight • Bucknell University, U.S.A. • 2008 Finalist

Pink and yellow columns seem to keep colliding or moving apart. But they never actually meet and never grow farther apart. In reality, the columns are not moving; the illusion of motion is created by spinning black-and-white diamonds within them.

ILLUSIONS FROM ROTATING RINGS

By Stuart Anstis and Patrick Cavanagh • University of California, San Diego, U.S.A., and Université Paris Descartes, France • 2011 Finalist

When the overlapping portions of these rings are opaque, the rings rotate as a single connected whole, as if welded

to each other. But when the overlapping portions appear transparent, the rings rotate as if they are separate and sliding over each other.

THE BREAK OF THE CURVEBALL
By Arthur G. Shapiro, Zhong-Lin Lu, Emily Knight, and Robert Ennis • American University; University of Southern California; Dartmouth College; and State University of New York College of Optometry, U.S.A. • 2009 First Prize
Arthur Shapiro and his colleagues showed that a baseball pitcher's curveball is an illusion created by the peripheral visual system of the batter. The ball rotates, certainly, but what that actually does—rather than physically changing the trajectory of the ball—is to bias the peripheral-motion sensors in the visual system of the batter in the direction of the spin. Viewing the image of a spinning ball as it exits your fovea—just as the image exits the batter's fovea as it approaches home plate—makes it look as if the ball is both spinning and curving.

CRAZY DIFFERENCES IN FOVEAL AND PERIPHERAL VISION
By Emily Knight, Arthur G. Shapiro, and Zhong-Lin Lu • Bucknell University and University of Southern California, U.S.A. • 2008 Finalist
This illusion is another striking example of the dichotomy between our foveal and our peripheral vision. Three visual targets appear to move horizontally when viewed directly, and diagonally when viewed from the corner of your eye.

THE INFINITE REGRESS ILLUSION
By Peter Tse • Dartmouth College, U.S.A. • 2006 Second Prize
Several of the illusions in the contest launched the analysis of peripheral perception in the new millennium. These perceptual effects highlight how our peripheral vision (but not our foveal vision) uses local motion cues within an object—such as the appearance of spinning—to indicate direction of motion. Tse employed this principle to make objects appear to move in specific (and wrong) directions infinitely.

IN A BIND
By Arthur G. Shapiro and Gideon Caplovitz • American University and University of Nevada, Reno, U.S.A. • 2011 Finalist
Two vertical bars, one red and one green, swept left and right across a screen. When the bars met in the middle of the screen, they changed colors and rebounded off each other, streaked back to the edge of the screen, and bounced back to the middle. Shapiro asked the audience to look at a spot above the screen while paying attention to the bouncing bars. People "oooooohed" as they saw the bars once again collide, but instead of ricocheting, now they seemed to pass through each other and retain their original color. Shapiro went on to show that the pass-through effect also works with textured, rather than colored, bars. This illusion shows that features bound to one object can rebind to a different moving object.

THE COLORED DOT ILLUSION
By Stuart Anstis • University of California, San Diego, U.S.A. • 2012 Finalist
A colored dot moves horizontally over a patterned black-and-white background. When you look straight at the dot, you see it accurately. But if you glance at the dot from the corner of your eye, it suddenly appears to glide diagonally. Anstis explained that this illusion demonstrates that our central vision sees positions very precisely, but our peripheral vision, better at seeing movement, is not well suited to determining position.

PERIPHERAL ACTION PHANTOM

By Steven Thurman and Hongjing Lu • University of California, Los Angeles, U.S.A. • 2012 Finalist

A figure appears to walk to the left when you view it directly. But wait! If you look away, the figure suddenly seems to change direction and walk to the right. Thurman and Lu positioned disks with blurry edges, called Gabor patches, to represent a person walking to the right, despite the overall leftward shift created by the motion of the texture within the disks. Our central vision does not pick up the subtle rightward-moving walking cues, but our super motion-sensitive peripheral vision grasps them at once and integrates them into our perception of the object's trajectory.

HEIGHT CONTRADICTION

By Sachiko Tsuruno • Kinki University, Japan • 2012 Finalist

The artist Sachiko Tsuruno built an architectural model that resembles the interior of a fortress and filmed balls rolling along inclines inside it. But because of the perspective of the camera, the balls seem to roll uphill between two level surfaces, as ridiculous and impossible as that may seem to your rational mind. Among the telltale signs: If you black out the staircase (a local clue), the top of the tower looks flat, whereas if you black out the sides (another local clue), it looks as if the top is on two levels connected by a staircase.

ROTATING McTHATCHER ILLUSION

By James Dias and Lawrence Rosenblum • University of California, Riverside, U.S.A. • 2014 Finalist

In the classic McGurk Effect, hearing the sound "ba" while viewing a face articulating "va" results in the observer's perception of the sound "va." Another classic illusion, the Margaret Thatcher Effect, shows that our visual systems are wired to see faces right side up, and thus fail to notice grotesque oddities when faces are upside-down. James Dias and Lawrence Rosenblum's illusion combines the McGurk and Thatcher effects and shows that our ability to read lips depends on face orientation. As a face rotates and becomes "Thatcherized," "ba" remains "ba": auditory perception becomes less susceptible to influence by the visual (i.e., facial) context.

ATTENTION TO MOTION

By Peter Tse, Patrick Cavanagh, David Whitney, and Stuart Anstis • Dartmouth College; University of California, San Diego, U.S.A.; Université Paris Descartes, France • 2011 Finalist

Red circles, perfectly aligned vertically, appear fixed to an axis that slants to the left or to the right, depending on where you allocate your attention. While the transparent layer of black dots rotates in one direction, the transparent layer of white dots rotates in the opposite direction, and the directions reverse every 1.2 seconds. When you focus on the white layer, the red circles appear slanted to the right; when you focus on the black layer, the circles appear slanted to the left.

PAC-MAN'S INFINITE MAZE

By Sebastiaan Mathôt and Theo Danes • Centre National de la Recherche Scientifique, Aix-Marseille Université, France • 2014 Finalist

This Pac-Man-inspired video game for Android is a demonstration of change blindness, which occurs when people fail to notice striking changes happening right in front of them, for lack of attention. You can enjoy the game just as if you were playing Pac-Man, with one key difference. What looks at first sight like a regular Pac-Man maze is in fact randomly re-generated with every move! The image is always centered on Pac-Man, and the maze scrolls across the display as Pac-Man moves. Even though the maze is constantly changing, most people take a long time to realize it. If the maze becomes static, as with a regular game of Pac-Man, the changes are easily noticeable.

THE DISAPPEARING FACES ILLUSION

By Stuart Anstis • University of California, San Diego, U.S.A. • 2014 Finalist

Visual neurons "adapt"—or gradually respond less vigorously—to unchanging stimuli. Adaptation to contrast is known to act specifically on the edges or contours in an image. Drawing on this principle, Anstis reasoned that adapting to a particular photograph should render the visual system less sensitive to that precise image, but not to similar, nonadapted photos with different contours. Anstis's illusion prompts your visual neurons to adapt to a flickering high-contrast photo of Albert Einstein on the left and one of Marilyn Monroe on the right. Once the flickering stops, two identical low-contrast overlays of Einstein and Monroe no longer look the same, but reveal Monroe on the left and Einstein on the right.

NOTES

INTRODUCTION

5 *you may underestimate or overestimate*: Russell E. Jackson and Lawrence K. Comack, "Evolved Navigation Theory and the Descent Illusion," *Perception & Psychophysics* 69, no. 3 (2007): 353–62.

1. BRIGHTNESS AND CONTRAST ILLUSIONS

10 *This illusion by Anderson and Winawer*: Barton L. Anderson and Jonathan Winawer, "Image Segmentation and Lightness Perception," *Nature* 434, no. 7029 (2005): 79–83, doi:10.1038/nature03271; B. L. Anderson and J. Winawer, "Layered Image Representations and the Computation of Surface Lightness," *Journal of Vision* 8, no. 7 (2008): 1–22, doi:10.1167/8.7.18.

12 *The neural bases of this effect*: "Dynamic Luminance," aka "Here Comes the Sun," aka "Luminance Star," published in *Bangor Daily News*, Sept. 11, 2006; in "The Art of Perception," *UMaine Today*, Sept.–Oct. 2007; and in Michael Baziljevich, *Sansenes Vidunderlige Verden*.

14 *If you look at a textured surface*: Lothar Spillmann, Joe Hardy, Peter Delahunt, Baingio Pinna, and John S. Werner, "Brightness Enhancement Seen Through a Tube," *Perception* 39, no. 11 (2010): 1504–13, doi:10.1068/p6765.

16 *The classical explanation*: G. Baumgartner, "Indirekte Grössenbestimmung der rezeptiven Felder der Retina beim Menschen mittels der Hermannschen Gitteräuschung," *Pflügers Archiv für die gesamte Physiologie des Menschen und der Tiere* 272: 21–22, doi:10.1007/BF00680926.

18 *This perceptual effect*: Mark Vergeer and Rob van Lier, "Capturing Lightness Between Contours," *Perception* 39, no. 12 (2010): 1565–78, doi:10.1068/p6539.

19 *contrast is an important cue*: Richard Russell, "A Sex Difference in Facial Contrast and Its Exaggeration by Cosmetics," *Perception* 38, no. 8 (2009): 1211–19, doi:10.1068/p6331; Richard Russell, "88: The Illusion of Sex," in *The Oxford Compendium of Visual Illusions*, ed. Arthur G. Shapiro and Dejan Todorović (Oxford, U.K.: Oxford University Press, 2017).

22 *Once neurons have adapted*: Stuart Anstis, "108: The Disappearing Faces Illusion," in *Oxford Compendium of Visual Illusions*.

2. COLOR ILLUSIONS

23 *an even more striking version*: Yuval Barkan and Hedva Spitzer, "109: The Color Dove Illusion—Chromatic

Filling In Effect Following a Spatial-Temporal Edge," in *The Oxford Compendium of Visual Illusions*, ed. Arthur G. Shapiro and Dejan Todorović (Oxford, U.K.: Oxford University Press, 2017).

24 *a single multicolored image*: Rob van Lier, Mark Vergeer, and Stuart Anstis, "Filling-In Afterimage Colors Between the Lines," *Current Biology* 19, no. 8 (2009): R323–24, doi:10.1016/j.cub.2009.03.010.

26 *Their illusion shows that a single image*: Mark Vergeer, Stuart Anstis, and Rob van Lier, "Flexible Color Perception Depending on the Shape and Positioning of Achromatic Contours," *Frontiers in Psychology* 6 (May 18, 2015), doi:10.3389/fpsyg.2015.00620.

28 *the vision scientist Michael White*: M. White, "A New Effect of Pattern on Perceived Lightness," *Perception* 8 (1979): 413–16.

28 *Purves's idea*: D. Purves, R. B. Lotto, S. M. Williams, S. Nundy, and Z. Yang, "Why We See Things the Way We Do: Evidence for a Wholly Empirical Strategy of Vision," *Philosophical Transactions of the Royal Society of London*, 356, no. 1407 (2001): 285–97.

3. SIZE ILLUSIONS

31 *Recent research shows that spiders*: M. W. Vasey, M. R. Vilensky, J. H. Heath, C. N. Harbaugh, A. G. Buffington, and R. H. Fazio, "It Was as Big as My Head, I Swear!: Biased Spider Size Estimation in Spider Phobia," *Journal of Anxiety Disorders* 26, no. 1 (2012): 20–24; D.M.T. Fessler, C. Holbrook, and J. K. Snyder, "Weapons Make the Man (Larger): Formidability Is Represented as Size and Strength in Humans," *PloS ONE* 7, no. 4 (2012): article e32751.

32 *the size of a moving object*: Ryan E. B. Mruczek, Christopher D. Blair, and Gideon P. Caplovitz, "Dynamic Illusory Size Contrast: A Relative-Size Illusion Modulated by Stimulus Motion and Eye Movements," *Journal of Vision* 14, no. 3 (2014): 2, doi:10.1167/14.3.2.

32 *Our own research showed*: J. Otero-Millan, S. L. Macknik, A. Robbins, M. McCamy, and S. Martinez-Conde, "Stronger Misdirection in Curved than in Straight Motion," *Frontiers in Human Neuroscience* 5 (2011): 133.

34 *Blair, Caplovitz, and Mruczek created*: Ryan E. B. Mruczek, Christopher D. Blair, Lars Strother, and Gideon P. Caplovitz, "The Dynamic Ebbinghaus: Motion Dynamics Greatly Enhance the Classic Contextual Size Illusion," *Frontiers in Human Neuroscience* 9 (Feb. 18, 2015), doi:10.3389/fnhum.2015.00077.

36 *The Fat Face Thin Illusion*: Peter Thompson, "Margaret Thatcher: A New Illusion," *Perception* 9, no. 4 (1980): 483–84, doi:10.1068/p090483; Peter Thompson and Jennie Wilson, "Why Do Most Faces Look Thinner Upside Down?" *i-Perception* 3, no. 10 (2012): 765–74, doi:10.1068/i0554.

37 *The Head Size Illusion demonstrates*: K. Morikawa, K. Okumura, and S. Matsushita, "Head Size Illusion: Head Outlines Are Processed Holistically Too," *Perception* 41 (2012), ECVP suppl., 115; Kazunori Morikawa, Soyogu Matsushita, Akitoshi Tomita, and Haruna Yamanami, "A Real-Life Illusion of Assimilation in the Human Face: Eye Size Illusion Caused by Eyebrows and Eye Shadow," *Frontiers in Human Neuroscience* 9 (March 20, 2015), doi:10.3389/fnhum.2015.00139; S. Matsushita, K. Morikawa, and H. Yamanami, "Measurement of Eye Size Illusion Caused by Eyeliner, Mascara, and Eye Shadow," *Journal of Cosmetic Science* 66, no. 3 (2015): 161–74.

4. SHAPE ILLUSIONS

40 *The circle on the left*: David Whitaker, Paul V. McGraw, David R. T. Keeble, and Jennifer Skillen, "Pulling the Other One: 1st- and 2nd-Order Visual Information Interact to Determine Perceived Location," *Vision Research* 44, no. 3 (2004): 279–86, doi:10.1016/j.visres.2003.09.014; Paul V. McGraw, David Whitaker, Jennifer Skillen, and Susana T. L. Chung, "Motion Adaptation Distorts Perceived Visual Position," *Current Biology* 12, no. 23 (Dec. 2002): 2042–47, doi:10.1016/s0960-9822(02)01354-4; Jennifer Skillen, David Whitaker, Ariella V. Popple, and Paul V. McGraw, "The Importance of Spatial Scale in Determining Illusions of Orientation," *Vision Research* 42, no. 21 (Sept. 2002): 2447–55, doi:10.1016/s0042-6989(02)00261-4.

48 *a novel variant of the Shepard Tabletop Illusion*: Lydia M. Maniatis, "Alignment with the Horizontal Plane: Evidence for an Orientation Constraint in the Perception of Shape," *Perception* 39, no. 9 (2010): 1175–84, doi:10.1068/p6681; Lydia Maniatis, "23: Symmetry and Uprightness in Visually-Perceived Shapes," in *The Oxford Compendium of Visual Illusions*, ed. Arthur G. Shapiro and Dejan Todorović (Oxford, U.K.: Oxford University Press, 2017).

50 *discovered this illusion serendipitously*: Lydia Maniatis, "24: Bath Tub Illusion," ibid.

52 *this illusion also works for a face*: Rob van Lier and Arno Koning, "The More-or-Less Morphing Face Illusion: A Case of Fixation-Dependent Modulation," *Perception* 43, no. 9 (Sept. 2014): 947–49, doi:10.1068/p7704.

52 *Our own research has shown*: Y. Chen, S. Martinez-Conde, S. L. Macknik, Y. Bereshpolova, H. A. Swadlow, and J. M. Alonso, "Task Difficulty Modulates the Activity of Specific Neuronal Populations in Primary Visual Cortex," *Nature Neuroscience* 11, no. 8 (2008): 974–82.

54 *how overall context affects*: Jisien Yang and Adrian Schwaninger, "Yang's Iris Illusion: External Contour Causes Length-Assimilation Illusions," *Japanese Psychological Research* 53, no. 1 (March 2011): 15–29, doi:10.1111/j.1468-5884.2010.00455.x.

55 *The Illusory Pyramid*: P. Guardini, "The Illusory Contoured Tilting and Rotating Pyramids," *Teorie e Modelli* 3 (2008): 323–34; Pietro Guardini and Luciano Gamberini, "Depth Stratification in Illusory-Contour Figures on Heterogeneous Backgrounds Is Independent of Contour Clarity and Brightness Enhancement," *Perception* 37, no. 6 (2008): 877–88; P. Guardini, "The Illusory Contoured Tilting (and Rotating) Pyramid," in *Il Posto della Fenomenologia Sperimentale nelle Scienze della Percezione*, Convegno-Workshop Università di Milano, Bicocca, Milano, Feb. 21–22, 2008.

56 *The neural bases of this illusion*: Stefano Guidi, Oronzo Parlangeli, Sandro Bettella, and Sergio Roncato, "Features of the Selectivity for Contrast Polarity in Contour Integration Revealed by a Novel Tilt Illusion," *Perception* 40, no. 11 (2011): 1357–75, doi:10.1068/p6897; Sergio Roncato and Clara Casco, "A New 'Tilt' Illusion Reveals the Relation Between Border Ownership and Border Binding," *Journal of Vision* 9, no. 6 (June 1, 2009): 14 (1–10), doi:10.1167/9.6.14; Sergio Roncato and Clara Casco, "Illusory Boundary Interpolation from Local Association Field," *Spatial Vision* 19, no. 6 (Nov. 1, 2006): 581–603, doi:10.1163/156856806779194008.

56 *"either because [the planets'] light is refracted"*: Galileo Galilei, *Dialogue Concerning the Two Chief World Systems*, trans. Stillman Drake (Berkeley and Los Angeles: University of California Press, 1953).

58 *This illusion by Bettella*: Sergio Roncato, "Brightness/Darkness Induction and the Genesis of a Contour," *Frontiers in Human Neuroscience* 8 (Oct. 20, 2014): 841, doi:10.3389/fnhum.2014.00841.

5. AMBIGUOUS ILLUSIONS

61 *the experimental psychologist Edwin Boring*: Edwin Boring, "A New Ambiguous Figure," *The American Journal of Psychology* 42, no. 3 (1930): 444–45.

61 *the vision scientist Gerald H. Fisher*: Gerald H. Fisher, "Mother, Father, and Daughter: A Three-Aspect Ambiguous Figure," *The American Journal of Psychology* 81, no. 2 (June 1968), pp. 274–77.

64 *The Ghostly Gaze Illusion*: Rob Jenkins, "The Lighter Side of Gaze Perception," *Perception* 36, no. 8 (2007): 1266–68, doi:10.1068/p5745; Rob Jenkins, John D. Beaver, and Andrew J. Calder, "I Thought You Were Looking at Me: Direction-Specific Aftereffects in Gaze Perception," *Psychological Science* 17, no. 6 (June 1, 2006): 506–13, doi:10.1111/j.1467-9280.2006.01736.x; Rob Jenkins and Christie Kerr, "Identifiable Images of Bystanders Extracted from Corneal Reflections," ed. Matthew Longo, *PLOS ONE* 8, no. 12 (Dec. 26, 2013): e83325, doi:10.1371/journal.pone.0083325.

6. PERSPECTIVE AND DEPTH ILLUSIONS

68 *the Leaning Tower Illusion*: Frederick A. A. Kingdom, Ai Yoonessi, and Elena Gheorghiu, "The Leaning Tower Illusion: A New Illusion of Perspective," *Perception* 36, no. 3 (2007): 475–77; Frederick A. A. Kingdom, Ali

Yoonessi, and Elena Gheorghiu, "Leaning Tower Illusion," *Scholarpedia* 2, no. 12 (2007); F.A.A. Kingdom, A. Yoonessi, and E. Gheorghiu, "Leaning Tower Illusion," in *The Oxford Compendium of Visual Illusions*, ed. Arthur G. Shapiro and Dejan Todorović (Oxford, U.K.: Oxford University Press: 2017).

71 *two different images can look identical*: Kimberley D. Orsten-Hooge, Mary C. Portillo, and James R. Pomerantz, "False Pop Out," *Journal of Experimental Psychology: Human Perception and Performance* 41, no. 6 (2015): 1623–33, doi:10.1037/xhp0000077.

72 *Skye's illusion*: Mathematics Awareness Month 2014 Poster, Penrose Tile Martin Gardner Rubin's Vase, www.mathaware.org/mam/2014/poster/; Martin Gardner Rubin's Vase Illusion: www.huffingtonpost.com /colm-mulcahy/martin-gardner_b_4125273.html; James Randi Rubin's Vase Illusion: http://turnermagic .com/2011/05/foreground-background-and-perspective/.

76 *Geiger and Ishikawa's illusion*: Davi Geiger, Hsingkuo Pao, and Nava Rubin, "Salient and Multiple Illusory Surfaces," *Proceedings of the IEEE Computer Society Conference on Computer Vision and Pattern Recognition*, 1998, pp. 118–24, cat. no. 98CB36231, doi:10.1109/cvpr.1998.698597; Hiroshi Ishikawa and Davi Geiger, "Illusory Volumes in Human Stereo Perception," *Vision Research* 46, nos. 1–2 (2006): 171–78, doi:10.1016/j.visres .2005.06.028; Gaetano Kanizsa, *Organization in Vision: Essays on Gestalt Perception* (New York: Praeger, 1979).

7. MOTION ILLUSIONS

79 *our own research has shown*: Xoana G. Troncoso, Michael B. McCamy, Ali Najafian Jazi, Jie Cui, Jorge Otero-Millan, Stephen L. Macknik, Francisco M. Costela, and Susana Martinez-Conde, "V1 Neurons Respond Differently to Object Motion Versus Motion from Eye Movements," *Nature Communications* 6 (2015): article 8114.

80 *the Spinning Disks Illusion*: Johannes M. Zanker, "85: Motion Illusions in Static Patterns," in *The Oxford Compendium of Visual Illusions*, ed. Arthur G. Shapiro and Dejan Todorović (Oxford, U.K.: Oxford University Press, 2017).

83 *Our previous research had shown*: S. Martinez-Conde, S. L. Macknik, X. G. Troncoso, and T. A. Dyer, "Microsaccades Counteract Visual Fading During Fixation," *Neuron* 49, no. 2 (2006): 297–305.

83 *The results, published in 2008*: X. G. Troncoso, S. L. Macknik, J. Otero-Millan, and S. Martinez-Conde, "Microsaccades Drive Illusory Motion in the *Enigma* Illusion," *Proceedings of the National Academy of Sciences of the United States of America* 105, no. 41 (2008): 16033-38.

83 *The neuroscientist Bevil Conway*: "Neural Basis for a Powerful Static Motion Illusion," *The Journal of Neuroscience* 25, no. 23 (2005): 5651–6.

87 *The Blurry Heart Illusion*: Kohske Takahashi, Shun'ya Yamada, Fuminori Ono, and Katsumi Watanabe, "Loss of Color by Afterimage Masking," *i-Perception* 4, no. 3 (2013): 144–46, doi:10.1068/i0584sas; Kohske Takahashi, Haruaki Fukuda, Katsumi Watanabe, and Kazuhiro Ueda, "Scintillating Lustre Induced by Radial Fins," *i-Perception* 3, no. 2 (2012): 101–103, doi:10.1068/i0488sas; Kohske Takahashi, Ryosuke Niimi, and Katsumi Watanabe, "Illusory Motion Induced by Blurred Red-Blue Edges," *Perception* 39, no. 12 (2010): 1678–80, doi:10.1068/p6811.

88 *magnificent example of how we perceive*: Hiroshi Ashida, Ichiro Kuriki, Ikuya Murakami, Rumi Hisakata, and Akiyoshi Kitaoka, "Direction-Specific FMRI Adaptation Reveals the Visual Cortical Network Underlying the 'Rotating Snakes' Illusion," *NeuroImage* 61, no. 4 (2012): 1143–52, doi:10.1016/j.neuroimage.2012.03.033; Akiyoshi Kitaoka, "Color-Dependent Motion Illusions in Stationary Images and Their Phenomenal Dimorphism," *Perception* 43, no. 9 (2014): 914–25, doi:10.1068/p7706; A. Kitaoka and S. Anstis, "Second-Order Footsteps Illusions," *i-Perception* 6, no. 6 (Dec. 24, 2015): 1–4, doi:10.1177/2041669515622085.

88 *in collaboration with Jorge Otero-Millan*: Jorge Otero-Millan, Stephen L. Macknik, and Susana Martinez-Conde, "Microsaccades and Blinks Trigger Illusory Rotation in the 'Rotating Snakes' Illusion," *Journal of Neuroscience* 32, no. 17 (April 25, 2012): 6043–51, doi:10.1523/jneurosci.5823-11.2012.

88 *Alex Fraser and Kimerly J. Wilcox discovered*: Alex Fraser and Kimerly J. Wilcox, "Perception of Illusory Move-ment," *Nature* 281 (October 18, 1979): 565–66.

88 *In a 2009 study, Jutta Billino*: J. Billino, K. Hamburger, and K. R. Gegenfurtner, "Age Effects on the Perception of Motion Illusions," *Perception* 38, no. 4 (2009): 508–21.

8. IMPOSSIBLE ILLUSIONS

95 *in 1958 published his observations*: L. S. Penrose and R. Penrose, "Impossible Objects: A Special Type of Visual Illusion," *British Journal of Psychology* 49, no. 1 (1958): 31–33.

96 *his magnetlike illusion*: Kokichi Sugihara, "Classification of Impossible Objects," *Perception* 11, no. 1 (Jan. 1982): 65–74; Kokichi Sugihara, "Design of Solids for Antigravity Motion Illusion," *Computational Geometry: Theory and Applications* 47, no. 6 (2014): 675–82; Kokichi Sugihara, "Ambiguous Cylinders. A New Class of Impossible Objects," *Computer Aided Drafting, Design and Manufacturing* 25, no. 3 (2015): 19–25.

99 *our brain interprets the bright streaks*: Dejan Todorović, "How Shape from Contours Affects Shape from Shading," *Vision Research* 103 (Oct. 2014): 1–10, doi:10.1016/j.visres.2014.07.014; Phillip J. Marlow, Dejan Todorović, and Barton L. Anderson, "Coupled Computations of Three-Dimensional Shape and Material," *Current Biology* 25, no. 6 (March 2015): R221–22, doi:10.1016/j.cub.2015.01.062.

9. MULTISENSORY AND NONVISUAL ILLUSIONS

108 *The mirage box*: Roger Newport and Helen R. Gilpin, "Multisensory Disintegration and the Disappearing Hand Trick," *Current Biology* 21, no. 19 (Oct. 2011): R804–805, doi:10.1016/j.cub.2011.08.044; Valeria Bellan, Helen R. Gilpin, Tasha R. Stanton, Roger Newport, Alberto Gallace, and G. Lorimer Moseley, "Untangling Visual and Proprioceptive Contributions to Hand Localisation over Time," *Experimental Brain Research* 233, no. 6 (June 2015): 1689–1701, doi:10.1007/s00221-015-4242-8.

110 *This tactile illusion*: M. Nakatani, R. D. Howe, and S. Tachi, "The Fishbone Tactile Illusion," in *Proceedings of EuroHaptics, 2006*, pp. 69–73, M. Nakatani, R. D. Howe, and S. Tachi, "Surface Texture Can Bias Tactile Form Perception," *Experimental Brain Research* 208, no. 1 (2011): 151–56, doi:10.1007/s00221-010-2464-3, PMID: 20981539.

10. ATTENTION ILLUSIONS

116 *we discovered some of the initial circuits*: Y. Chen, S. Martinez-Conde, S. L. Macknik, Y. Bereshpolova, H. A. Swadlow, and J. M. Alonso, "Task Difficulty Modulates the Activity of Specific Neuronal Populations in Pri-mary Visual Cortex," *Nature Neuroscience* 11, no. 8 (2008): 974–82.

117 *create a variation*: Daniel J. Simons, "Monkeying Around with the Gorillas in Our Midst: Familiarity with an Inattentional-Blindness Task Does Not Improve the Detection of Unexpected Events," *i-Perception* 1, no. 1 (2010): 3 6, doi:10.1068/i0386.

120 *three semitransparent overlapping circles*: P. U. Tse, "Voluntary Attention Modulates the Brightness of Overlapping Transparent Surfaces," *Vision Research* 45, no. 9 (2005): 1095–98, doi:10.1016/j.visres.2004.11.001.

124 *Tse showed that attention*: Eric A. Reavis, Peter J. Kohler, Gideon P. Caplovitz, Thalia P. Wheatley, and Peter U. Tse, "Effects of Attention on Visual Experience During Monocular Rivalry," *Vision Research* 83 (2013): 76–81, doi:10.1016/j.visres.2013.03.002.

CONTRIBUTOR BIOGRAPHIES

Arash Afraz was born in Tehran in 1974. He received his M.D. from Tehran University of Medical Sciences and his Ph.D. from Harvard University. He is currently a scientist at MIT, studying visual object recognition in the brain. Arash is also a photographer; he believes in no solid boundaries between art and science. In his current work, Arash combines scientific knowledge of visual processing in the brain with aerial photography techniques to blur the line between art and science and create new visual experiences.

Barton Anderson is a professor at the University of Sydney in Australia, where he studies various problems in vision, including perceptual organization, segmentation, grouping, and surface attributes such as color, material composition, and shape.

Stuart Anstis was born in England and studied at the University of Winchester and at Cambridge University, where he was Richard Gregory's first graduate student. He is a professor of psychology at UC San Diego, a Humboldt Fellow, a Koffka medalist, and a visiting fellow at the University of Oxford's Pembroke College. He has been a visiting scientist at the Smith-Kettlewell Eye Research Institute in San Francisco, the San Francisco Exploratorium, and IPRI in Japan. Working with international collaborators, he has published some 170 articles on visual perception.

Yuval Barkan received a B.Sc. degree in physics, a B.Sc. in electrical engineering, and an M.Sc. in biomedical engineering from Tel Aviv University, where he is currently a Ph.D. candidate. His research interests have focused on understanding the mechanisms behind visual illusions and developing computational models and algorithms that leverage this knowledge to engineering and biomedical needs.

Sandro Bettella has been a laboratory technician in the Department of General Psychology at the University of Padua since 1973. He has conducted research in attention, vision, visual and auditory perception, memory, psycholinguistics, neurophysiology, neural networks, virtual reality, and face recognition in newborns. He has discovered several illusions while processing visual stimuli for experimental purposes.

Christopher Blair obtained his master's and Ph.D. in psychology at the University of Nevada, Reno, while working in the Caplovitz Vision Lab, where he studied topics ranging from size, form, and motion perception to syn-

esthesia. He is currently a postdoctoral fellow at McGill University, in Dr. Jelena Ristic's Laboratory for Attention and Social Cognition, where he investigates the neural correlates of directed attention.

Gianluca Campana is an associate professor of general psychology at the University of Padua. He received his Ph.D. from the University of Padua and was subsequently awarded a postdoctoral Marie Curie Fellowship at the University of Oxford. His work has covered various aspects of vision science and neuroscience, including perceptual priming, perceptual learning, and visual motion processing, which he has investigated with psychophysics and noninvasive brain-stimulation techniques. He has published more than forty articles in international peer-reviewed journals.

Gideon Caplovitz is a cognitive neuroscientist who researches the principles and neural mechanisms that underlie how we visually experience the world. He received his Ph.D. in cognitive neuroscience from Dartmouth College and did postdoctoral training at Princeton University. In addition, he has a master's degree in mathematics from the Courant Institute of Mathematical Sciences at NYU, and has completed internships at the Naval Undersea Warfare Center, AT&T Bell Laboratories, and Lucent Technologies. He has received funding for his research from the National Science Foundation and the National Institutes of Health and is currently an associate professor of psychology at the University of Nevada, Reno.

Clara Casco was born in Martignacco, in Udine, Italy, and is currently a professor of visual psychophysics and brain development and aging at the University of Padua. Her research interests include motion perception, texture segmentation, perceptual learning and brain plasticity, and low-vision rehabilitation.

Peter Delahunt received a B.S. in psychology from Lancaster University, U.K., in 1996. He earned his M.A. (1998) and Ph.D. (2001) in psychology from UC Santa Barbara, under the supervision of Dr. David Brainard. He was then a postdoctoral fellow with Dr. John Werner at the UC Davis Medical Center, where he studied the effects of aging on visual perception. Dr. Delahunt currently works at Posit Science, where he helps develop and evaluate visual training exercises designed to improve brain function across the life span.

Luciano Gamberini is a professor of work and organizational psychology at the University of Padua in Italy, where he is also the director of the Human Inspired Technology Research Centre, the vice director of the Ph.D. School in Brain, Mind and Computer Science, and the cofounder of the Human Technology Lab (HTLab). His research interests include human-computer interaction, information visualization, ergonomics, work psychology, and applied cognitive science.

Davi Geiger is a professor at the Courant Institute of Mathematical Sciences and at the Neural Science Center at NYU. He received his Ph.D. in physics from MIT and is a recipient of the National Science Foundation CAREER Award.

Elena Gheorghiu is a lecturer in psychology at the University of Stirling, U.K. She obtained her Ph.D. in physics from the University of Utrecht, The Netherlands, and worked as a postdoctoral research fellow at McGill University, Canada, and the University of Leuven, Belgium. Her studies of human vision focus on elucidating the relationship between the low-level stages of vision that detect simple features and the intermediate-to-higher stages of vision that connect these features to form surfaces and shapes. Her research interests include shape processing, curvature, contour and texture perception, stereopsis, color, motion, and symmetry processing.

Helen Gilpin was a psychology undergraduate at the University of Nottingham when, in 2011, she was the first to use the Disappearing Hand Trick experimentally, discovering that it temporarily changes the brain's mental representation of the body. She conducted more experiments with the illusion for a brief spell with the Body in Mind research group in Adelaide, Australia, and is currently training to be a clinical psychologist.

During his degree course in psychology, **Pietro Guardini** began working in the Virtual Reality Lab of the general psychology department at the University of Padua as a research assistant and developer. His research projects focused mainly on the usability of virtual environments. The unique opportunity to handle VR hardware, as well as software for the construction of 3-D environments, allowed him to study visual illusions in exotic new contexts. That is how the Illusory Contoured Tilting Pyramid was born. Thanks to his interest in human–computer interaction and his passion for video games, he entered the video game industry in 2008 with the task of introducing user research activities to Milestone, the major video game studio in Italy. In 2016, he decided to work independently and extended his services and analyses to other developers.

Kai Hamburger received his diploma in psychology from the University of Frankfurt in 2004. From 2005 to 2007, he was a Ph.D. student at the University of Giessen under Professor Karl R. Gegenfurtner. Currently, he is an assistant professor at the University of Giessen. His main research topics are spatial cognition (human way-finding) and consciousness.

Joe Hardy is a technologist and an inventor. He received his Ph.D. in cognitive psychology from UC Berkeley and performed postdoctoral research at the UC Davis Medical Center. He also has a master's in business administration from the Haas School of Business at UC Berkeley.

Eri Ishii was a student at the School of Human Sciences, Osaka University, advised by Kazunori Morikawa.

Hiroshi Ishikawa received his B.S. and M.S. degrees in mathematics from Kyoto University and his Ph.D. degree in computer science from NYU. In 2010, after working at Nagoya City University, he became a full professor at the Department of Computer Science and Engineering, Waseda University, Tokyo. He received the PRESTO and CREST Grants from the Japan Science and Technology Agency. He has also received the NYU Courant Institute's Harold Grad Memorial Prize, the IEEE Computer Society Japan Chapter Young Author Award, and the MIRU Nagao Award. He is on the editorial board of the *IEEE TPAMI* and *IJCV*.

Rob Jenkins obtained a degree in cognitive science at the University of Westminster, followed by a Ph.D. in the psychology department of University College London. His research interests include face perception and social interaction. He has published on these topics in *Science*, *Current Biology*, *Psychological Science*, and other journals. In 2007 he was awarded the British Science Association's Joseph Lister Prize for science communication, and in 2012 the Royal Society of Edinburgh's Sir Thomas Makdougall Brisbane Early Career Prize for physical sciences. Rob Jenkins is a member of the RSE Young Academy of Scotland. In 2012, he was elected to the Global Young Academy.

Ryota Kanai is the founder and CEO of the Tokyo-based start-up Araya Brain Imaging, which aims to understand consciousness and then to apply concepts of conscious computing to artificial intelligence. He is also an affiliated reader (associate professor) at the Sackler Centre for Consciousness Science at the University of Sussex. He obtained his Ph.D. in psychophysical studies of visual awareness from Utrecht University in The Netherlands in 2005 and continued his research into visual awareness at the California Institute of Technology and at University College London.

Frederick Kingdom is a professor at McGill University who has been studying human vision for over thirty-five years. He gained his B.A. at the University of Cambridge and a Ph.D. at the University of Reading. In 1990, after postdoctoral research at the universities of Reading and Cambridge, he took up a faculty position at McGill, where he has continued to work until this day. His main research interests lie in the intermediate stages of human vision, encompassing color vision, stereopsis, texture perception, contour-shape coding, brightness, lightness, transparency, and the study of visual illusions. His preferred methodology is psychophysics, often incorporating the use of image-processed photographs of natural scenes.

Akiyoshi Kitaoka is a professor of psychology at the College of Comprehensive Psychology, Ritsumeikan University, Osaka/Kyoto, Japan. He extensively studies visual illusions, including geometrical (shape) illusions, lightness illusions, color illusions, motion illusions, and other visual phenomena, including visual completion and perceptual transparency. He also produces a variety of "illusion works" and exhibits them on his websites. His most popular creation is the Rotating Snakes Illusion, which he created in 2003 as an optimization of the Fraser-Wilcox Illusion.

Arno Koning graduated from the University of Amsterdam in 1999, and gained his Ph.D. in 2004 at the current Donders Centre for Cognition at the Radboud University in Nijmegen, The Netherlands, with Dr. Rob van Lier, in the domain of 3-D object perception. Following a postdoctoral period at the University of Leuven (Belgium) with Professor Johan Wagemans, he has been a staff member of Dr. van Lier's Perception and Awareness Lab at the Donders Centre for Cognition since 2008, as well as coordinator of the Cognitive Neuroscience Research Master Programme of the Donders Graduate School for Cognitive Neuroscience.

Lydia M. Maniatis learned almost everything she knows about vision by studying the work of the great Gestalt psychologists: Wertheimer, Köhler, Koffka, Arnheim, Kanizsa, Goldmeier, and others. She received her Ph.D. at American University in Washington, D.C., where, with great patience, Dr. Scott R. Parker helped her organize her thoughts.

Kazunori Morikawa is professor of psychology at the School of Human Sciences, Osaka University, Japan. He graduated from the University of Tokyo, then received his Ph.D. in cognitive psychology from Stanford University. His research interests include visual illusions, face perception, memory, spatial cognition, and behavioral economics. He is especially interested in useful visual illusions that occur in our daily lives, such as illusions caused by clothing and cosmetics.

Ryan Mruczek received his Ph.D. in neuroscience from Brown University and completed his postdoctoral training at Princeton University and the University of Nevada, Reno. He is currently an assistant professor at Worcester State University. His research focuses on understanding how the brain efficiently processes sensory information in order to construct a functional representation of the outside world. He uses a wide array of methods in his work, including psychophysics, electrophysiology, and neuroimaging. His most recent work has explored the effects of motion dynamics on classic visual size illusions.

After receiving a Ph.D. in information physics and computing at the University of Tokyo, **Masashi Nakatani** worked for four years in the cosmetics industry, where he developed a sensor system that evaluates skin softness. He returned to academic research in the spring of 2012 and started a neuroscientific study of touch at Keio University in Japan and at Columbia University Medical Center, uncovering physiological characteristics of Merkel cells as a light-touch receptor in the skin. He is currently affiliated with Hokkaido University, where he conducts comprehensive studies of skin sensation, from cellular biology to human tactile perception.

Ken Nakayama is the Edgar Pierce Professor of Psychology at the Department of Psychology, Harvard University. From 1971 to 1990, he worked at the Smith-Kettlewell Eye Research Institute in San Francisco. He received a B.A. from Haverford College and a Ph.D. from UCLA. He was a founder and the first president of the Vision Sciences Society. Professor Nakayama has worked on multiple aspects of visual perception, and is best known outside of academia for his contributions to the understanding of prosopagnosia, the inability to recognize familiar faces.

Kaia Nao is a pseudonym used for the graphic optical art of Joe Hautman, known for his paintings of wildlife. Hautman's formal education is in the physical sciences. He earned a Ph.D. in theoretical physics from the University of Michigan in 1985 but turned his lifelong interest in art into a new career after winning a national art contest in 1991. His studies of the techniques of realistic painting led him to explore some of the optical illusions that he encountered unintentionally while painting. These studies led to a catalogue of images, under the name Kaia Nao, that were collected either because of their novel illusory effects or just for their beauty.

Roger Newport is a psychology lecturer at the University of Nottingham. In 2008, he invented a mediated reality system for manipulating vision of the hands in real time, for the purpose of stroke rehabilitation. While reassembling the equipment after moving labs one day, he was calibrating the camera by lining up his own right hand. Because the system was misaligned, his right hand was not where he perceived it to be, with the result that when he reached for a screwdriver in his left hand, just out of sight, he was astonished to find only empty space. This provided his inspiration for the Disappearing Hand Trick.

Ryosuke Niimi is an associate professor in the Department of Psychology, Faculty of Humanities, Niigata University, Japan. He has studied various aspects of human visual cognition, such as object recognition, scene perception, attention, visual preference, and symmetry perception, through methods of experimental psychology and neuroscience.

Anthony M. Norcia is research professor of psychology at Stanford University, where he works on human vision and visual development. His research focuses on spatial vision, approached through neuroimaging, behavioral, and computational approaches. Before coming to Stanford, Norcia was a scientist at the Smith-Kettlewell Eye Research Institute in San Francisco. He received his Ph.D. in physiological psychology from Stanford University and did his postdoctoral training at Brown University under Lorrin Riggs.

Kimberley Orsten-Hooge received her B.S. in psychology from the University of Houston-Downtown, her M.Sc. in cognitive neuropsychology from Oxford Brookes University, and her Ph.D. in psychology from Rice University. Her doctoral work on False Pop Out—a phenomenon in which identical items look different from one another and different items look identical to each other—stemmed from her interest in illusions and inspired the illusion A Turn in the Road. Her postdoctoral research at the University of Arizona continues to focus on perceptual organization phenomena and the influence of neural feedback on object detection.

Baingio Pinna has been a professor of experimental psychology and visual perception at the University of Sassari, Italy, since 1995. From 2001 to 2002, he received a research fellowship from the Alexander Humboldt Foundation in Freiburg, Germany, and was the winner of a scientific productivity prize at the University of Sassari in 2007. His main research interests lie in Gestalt psychology, visual illusions, the psychophysics of perception of shape, motion, color, and light, and the science of visual art.

James R. Pomerantz is a psychology professor at Rice University, having earned his B.A. from the University of Michigan and his Ph.D. from Yale. He has worked at Bell Laboratories, Yale, Johns Hopkins, SUNY Buffalo, and Brown University, where he was provost and acting president. He is a fellow of the American Psychological Association and the Society of Experimental Psychologists, and served as president of the Federation of Associations in Behavioral and Brain Sciences. His research deals with perceptual organization and emergent features in vision that make wholes different from the sums of their parts. His work on illusions includes the rubber-pencil illusion, the "grass is always greener" effect, and illusory pausing.

Sidney Pratt is a tobaccologist with twenty-five years of experience treating cigarette addiction. His studies have been with the Institute for Global Tobacco Control at Johns Hopkins Bloomberg School of Public Health, University of Massachusetts Medical School, Quit Smart, and Duke University. He is currently negotiating a research project with the Department of Epidemiology and Public Health, Comprehensive Drug Research Center, Miller School of Medicine at the University of Miami, the overall objective of which is to generate evidence in support of the efficacy of the "Pratt Blindfold" as an intervention for smoking cessation.

Catherine Preston completed a B.Sc. in psychology with neuroscience at the University of Leicester in 2004, and then a Ph.D. in psychology at the University of Nottingham in 2008. She stayed as a postdoc at the University of Nottingham until 2010, when she took a position as temporary lecturer at Nottingham Trent University. In 2011, Preston moved to the Karolinska Institutet in Stockholm, where she won the Wenner-Gren and the Marie Curie Intra-European Fellowship. She started her lectureship at the University of York in 2015. Preston's research interests focus on self-awareness and body perception, particularly in relation to clinical disorders and underlying neural mechanisms. She uses multisensory body illusions and functional magnetic resonance imaging (fMRI) to examine the perceptual and emotional malleability of the experience of the body in both the healthy and the abnormal brain.

Sergio Roncato was born in Noale, in Veneto, Italy. He received the Laureate in Sociology from the University of Trento in 1971. He has been a professor of general psychology and perceptual psychology at the University of Padua since 1982. His research interests include cognitive processes, knowledge representation, vision processes, art and perception, and optical-geometrical illusions. His experimental activity is mainly focused on the role of photometric factors (particularly the sign of luminance contrast) in perceptual organization.

Richard Russell is a perceptual psychologist. His research applies techniques and knowledge from vision science to answer questions about how we perceive people. A major focus of his research is the development of a biologically based account of makeup and other techniques of personal decoration. He has degrees from Pomona College and MIT, and has done research at Cambridge University, USC, Harvard, and the University of St. Andrews. He is on the faculty at Gettysburg College.

Gianni A. Sarcone is a bestselling author of educational books and a researcher in the field of visual perception and communication. He is the cofounder and CEO of Archimedes Laboratory Project, a consulting network of experts specializing in improving and developing creativity. Marie-Jo Waeber is the other cofounder, and Dr. Courtney Smith is the assistant manager. Sarcone's work and research has been covered by major scientific and art magazines or news agencies, among them *Scientific American*, *National Geographic Kids*, *New Scientist*, CNN, *Smithsonian*, *Focus* (Italy), *Query* (Italy), *Tangente* (France), and *Science & Vie* (France).

Adrian Schwaninger is currently the vice-director of the School of Applied Psychology of the University of Applied Sciences and Arts Northwestern Switzerland (FHNW).

Arthur G. Shapiro is an American vision scientist and co-editor of *The Oxford Compendium of Visual Illusions*. He is professor of psychology and chair of computer science at the American University in Washington, D.C. He is director of the Collaborative for Applied Perceptual Research and Innovation (CAPRI). Shapiro completed his undergraduate work in mathematics and psychology at UC San Diego, his Ph.D. in psychology at Columbia University, and his postdoctoral research in the Department of Ophthalmology and Visual Sciences at the University of Chicago. His research focuses on color, motion, vision in low-light environments, and visual phenomena. Shapiro's research has been featured in news articles, television programs, and viral videos, including the television series *Brain Games* and a five-part series about illusions on CuriosityStream. Shapiro is a member of the "Nifty Fifty," a group organized by the USA Science and Engineering Festival to promote the STEM (Science, Technology, Engineering, and Mathematics) fields to secondary school students.

Daniel Simons is a professor of psychology at the University of Illinois, where he heads the Visual Cognition Laboratory. After receiving his Ph.D. in experimental psychology from Cornell University, he spent five years on the faculty at Harvard University before moving to Illinois in 2002. His research explores the limits of awareness and memory. He is co-author, with Christopher Chabris, of *The Invisible Gorilla*, a book that explores our mistaken intuitions about how our minds work.

Pawan Sinha is a professor of vision and computational neuroscience at MIT, where he studies human visual cognition via experimental and computational approaches. He funded Project Prakash, a humanitarian program that uses visual neuroscientific advances to provide functionally blind Indian children with eyesight. In 2012, he received the Presidential Early Career Award for Scientists and Engineers.

Victoria Skye is an illusion artist and a professional magician. She uses her talents from her magic, her previous mechanical-drafting career, and her woodworking background to create optical illusions, impossible objects, and puzzles. Skye's award-winning art is published in numerous books and articles in the math, magic, science, and puzzle genres. Magicians and metagrobologists around the world collect her illusions.

Lothar Spillmann studied Gestalt psychology and single-cell correlates of visual perception at the universities of Münster and Freiburg. He was a postdoctoral fellow at MIT, the Retina Foundation, and the Massachusetts Eye and Ear Infirmary in Boston from 1964 to 1971, and the head of a psychophysics laboratory at Freiburg from 1971 to 2005. He cofounded the European Conference on Visual Perception in 1978. He has conducted studies of contrast, brightness, neon-color, watercolor, and movement illusions and their underlying neurophysiological mechanisms. With John S. Werner, he edited *Visual Perception: The Neurophysiological Foundations* and translated into English W. Metzger's *Laws of Seeing* and M. Wertheimer's *On Perceived Motion and Figural Organization*. He is currently a visiting professor in Taiwan, Hong Kong, and Shanghai.

Hedva Spitzer received her B.A. in biology, and her M.A. and Ph.D. in electrophysiology, from the Hebrew University of Jerusalem. She heads the Vision Research Laboratory in the School of Electrical Engineering at Tel Aviv University. The laboratory focuses on human perception and visual psychophysics, visual computational neuroscience, and derived algorithms for image processing and computer vision. Her research interests in recent years have focused on luminance, color, visual adaptation mechanisms, natural and medical high-dynamic-range images, textures, illusory contours, lateral facilitation mechanisms, chromatic aberrations and their applications to natural and medical image enhancement, segmentation, and classification.

Donald Alan Stubbs, Ph.D. (George Washington University, 1967), was professor of psychology and cooperating professor of art and new media at the University of Maine. Alan's teaching included courses in experimental psychology, especially perception and learning, photography, and information design. Many of his publications are found at ResearchGate.net, and his career is described in "In Memoriam D. Alan Stubbs: 1940–2014," *Journal of the Experimental Analysis of Behavior* 103, no. 2 (2015): 267–68. In addition to his work with illusions, such as "Dynamic Luminance" (also known as "Here Comes the Sun"), Alan had numerous photographs in juried shows. His final completed project documented sculptors and their sculptures for the Schoodic International Sculpture Symposia IV-V. Many summers, Alan volunteered his time and expertise in mentoring aspiring high school students in the Upward Bound Math Science Program at UMaine. Besides his passion for the visual arts, Alan loved music and was a "darn good drummer."

Kokichi Sugihara received a Dr.Eng. in mathematical engineering from the University of Tokyo in 1980. He worked at the Electrotechnical Laboratory of the Ministry of International Trade and Industry of Japan, Nagoya University, and the University of Tokyo, and is now a professor at Meiji University. His research areas include computer vision, computational geometry, robust computation, computer graphics, and computational illusion. He found a method for realizing impossible objects in a 3-D space without using traditional tricks, and extended the method to design new classes of 3-D illusions, such as impossible motion and ambiguous cylinders.

Kohske Takahashi is an associate professor at the School of Psychology at Chukyo University, Japan. His research covers broad topics in cognitive psychology and cognitive neuroscience, including psychological, visual, and optical illusions. He is also interested in entomophagy. He has received several awards for his illusions, including second prize in the 2012 Illusion Contest in Japan and the first and tenth prizes in the 2013 Illusion Contest, also in Japan. He has a Ph.D. in informatics from Kyoto University.

Peter Thompson is a professor of psychology at the University of York, where he has held a position since 1978. In 1990, he was a U.S. National Research Council senior research associate, visiting NASA's Ames Research Center. His interests and publications are wide-ranging, from low-level mechanisms of motion and orientation processing to face perception and visual aftereffects and illusions.

Dejan Todorović is a member of the Department of Psychology at the University of Belgrade, Serbia. He holds a B.A. degree in mathematics from the University of Belgrade and a Ph.D. in psychology from the University of Connecticut. He spent time at Boston University, Rutgers University, the University of Toronto, and the Center for Interdisciplinary Research at Bielefeld University (Germany). He uses psychophysical experimentation, computer modeling, and mathematical analyses to study the perception of various features of spatial geometry and achromatic color.

Peter Ulric Tse was born in 1962 in New York City. He studied physics and math at Dartmouth College from 1980 to 1984, then lived in Nepal, Germany, China, and Japan before beginning graduate school in cognitive psychology at Harvard University in 1992. From 1998 to 2001, he was a postdoctoral fellow doing fMRI (functional magnetic resonance imaging) in Nikos Logothetis's monkey neurophysiology lab at the Max Planck Institute. He has been a professor of cognitive neuroscience at Dartmouth College since 2001, and lives with his family on what was once a farm in rural New Hampshire.

Christopher Tyler received his training in experimental psychology at the universities of Leicester, Aston, and Keele before taking postdoctoral fellowships at Northeastern University (Boston), the University of Bristol, and Bell Laboratories. He then took up a position at the Smith-Kettlewell Eye Research Institute, where he retains an

affiliation, and has taught courses at Northeastern, UCLA, UC Santa Barbara, UC Berkeley, and the University of Paris along the way. He has had widespread collaborations across the globe and has given numerous keynote addresses to scientific meetings across many disciplines, from microscopy to Renaissance art.

Rob van Lier studied physics and mathematics at a teachers' academy and experimental psychology at the Radboud University (Nijmegen, The Netherlands). After that, he obtained his Ph.D. with a dissertation on the role of regularities and structural descriptions in shape perception (1996). He spent a two-year postdoc period at the University of Leuven (Belgium). Currently, he is an associate professor and a principal investigator at the Donders Institute for Brain, Cognition and Behaviour, where he heads the Perception and Awareness group, studying various topics in perception (e.g., visual illusions, color-contour interactions, filling in, cross-modal perception, vision and art).

Mark Vergeer is a postdoctoral researcher at the University of Minnesota. His research focuses on (un)conscious vision, perceptual organization, and color perception. His illusions have competed in the Best Illusion of the Year Contest in multiple years, receiving first prize in 2008 and 2015, and second prize in 2014.

Katsumi Watanabe is a professor of cognitive science at Waseda University and visiting associate professor at the University of Tokyo. He received a B.A. in experimental psychology and an M.A. in life sciences from the University of Tokyo, and a Ph.D. in computation and neural systems from the California Institute of Technology for his work in cross-modal interaction in humans. He was a research fellow at the National Institutes of Health in the United States, and a researcher at the National Institute of Advanced Industrial Science and Technology in Japan. His research interests include scientific investigations of explicit and implicit processes, interdisciplinary approaches to cognitive science, and real-life applications of cognitive science.

John S. Werner is a distinguished professor at UC Davis in the departments of ophthalmology and neurobiology. His primary research interest is in the early-stage mechanisms of color and spatial vision. He uses illusions and eye diseases as probes to understand visual system computations.

David Whitaker is an optometrist and professor of vision science at Cardiff University, Wales. His research interests include spatial vision (hyperacuities, peripheral vision, and the interactions between first- and second-order vision) and multisensory time perception, specifically the illusory interactions between the different senses. He sat as a member of the Allied Health Professions panel on the U.K.'s 2014 Research Excellence Framework.

Jonathan Winawer is an assistant professor of psychology and neural science at NYU, where he studies how visual stimuli are encoded in the human visual pathways, and how this encoding process relates to visual perception. He studies image encoding by measuring and modeling signals obtained by magnetic resonance imaging (MRI), electroencephalography (EEG), and electrocorticography (ECoG), in combination with behavioral measures (psychophysics).

Yang's Iris Illusion was accidentally discovered by **Jisien Yang** when he prepared his experimental materials for research during his doctoral program at the University of Zurich, Switzerland. His adviser, Professor Adrian Schwaninger, encouraged him to explore the mechanisms behind the illusion. The length-perception distortion was especially fascinating because of its opposite effect in Caucasian and Asian faces. Jisien Yang earned his doctorate in 2010 with insigni cum laude, and is currently an assistant professor in the Department of Social Work at the National Quemoy University (Taiwan).

Ali Yoonessi is an assistant professor of neuroscience at Tehran University of Medical Sciences. After graduating as a medical doctor in 1998, he continued his education with a Ph.D. in visual neuroscience at McGill University. He completed his postdoctoral research fellowship at McGill University and later at the State University of New York. He has published numerous articles in peer-reviewed journals, and has presented his research at national and international meetings. His research and clinical interests include color vision, visual psychophysics, and early changes in post-receptoral channels of the visual system in Alzheimer's disease, multiple sclerosis, and addiction.

Trained as a biologist with a focus on cybernetics, **Johannes M. Zanker** has held various positions at research institutes and universities in Germany, Italy, Australia, and the United Kingdom, and is now working as professor of neuroscience in the Department of Psychology at Royal Holloway, University of London. His research covers a wide range of topics in perceptual, behavioral, and computational aspects of vision, including flight control and navigation in insects, visual ecology, visual development, human psychophysics, camouflage, eye movements, and experimental aesthetics. A major theme of his work is the computational modeling of motion perception and visual illusions.

ACKNOWLEDGMENTS

To put together the annual Best Illusion of the Year Contest requires the proverbial village. In the thirteen contests so far, literally hundreds of people have helped make the event a success, first and foremost, the illusion creators—the incredibly observant and ingenious discoverers of unusual misperceptions who participate year after year in the contest. Without them, there would be no competition.

This book features the top ten illusions for each year of the first decade of the contest, and you can see the top ten finalists of subsequent editions on the contest's website, which is updated yearly. But for every illusion that you enjoy in the website archive, there were countless others that never saw the light of day. Many of these creations—even though they were not selected to compete among the top ten—were also wonderful. Alas, the format of the contest requires that only ten illusions compete per year. We owe a debt of gratitude to each individual participant.

The illusionists showcased in this book were amazingly generous in providing their time and expertise to help us develop a deeper understanding of their creations, as well as the circumstances of their discoveries. They have guided many aspects of this project, answering very kindly our requests for information, fact-checking, and proofreading, usually with extremely short deadlines. Any errors in the descriptions are ours; the brilliance of the illusions is all theirs.

We are greatly indebted to our good friend Lothar Spillmann, who has been a constant supporter of our research and science communication over the years. Lothar encouraged us to host the European Conference on Visual Perception, which led to the birth of the Best Illusion of the Year Contest, and he gave us tons of great advice along the way.

The first edition of the contest, held during the ECVP meeting in 2005, was co-hosted by the Museos Científicos Coruñeses (Scientific Museums of A Coruña) and Dygrafilms. We thank Marcos Pérez (technical director of Casa de las Ciencias) and Ramón "Moncho" Núñez Centella (one of the premier science communicators in the world, and at the time director of the MC²) for their unwavering support and enthusiasm for our joint project. Marcos and Moncho were the first to teach us how to communicate exciting science to nonspecialists, and this book might not exist had we not met them. Our good friend Luis Martinez, who lived in A Coruña at the time of the conference, single-handedly ran its local organization.

Making the contest into an annual event required the formation of a nonprofit organization, which we called the Neural Correlate Society. Luis Martinez, together with our close friends Jose-Manuel Alonso, Peter Tse, and Xoana Troncoso, joined us as founding members and have served on the NCS executive board since 2006. Their guidance and strong vision have been an indispensable anchor.

Our deepest thanks go to the scientists and artists who emceed and performed at the contest for the first ten years. Susana emceed the first contest in Spain, but future contests were emceed by our colleagues and friends Denis Pelli, Margaret Livingstone, Stuart Anstis, and Peter Thompson (the latter two emceed the contest multiple times, for which we are more grateful than we can say). Mac King generously donated his time to emcee and perform at the contest's unforgettable tenth anniversary in Saint Petersburg, Florida. James Randi (aka The Amaz!ng Randi) performed at two consecutive contests. Other performers included Thomas Blacke, holder of the Guinness World Record for the Fastest Handcuff Escape Blindfolded and the Guinness World Record for the Fastest Escape from Handcuffs Underwater; the marvelous cellist E. Zoe Hassman, whom we met at a concert in the home of our good friend and colleague Mickey Goldberg; and the Professors (Tim and Tanya Chartier).

The artist Cándido Novo created an original and exclusive sculpture that served as the first-prize trophy awarded in the first year of the contest. The sculptor Guido Moretti donated the illusion trophies that were awarded to the top three winners in the second through the tenth years of the contest. We were fortunate to meet Guido in person in 2010, when he traveled from Italy to Naples, Florida, to attend the contest's sixth gathering.

Many illusion experts and creators have served as international judges, paring down dozens of illusion submissions to the top ten every year. We thank them all for their efforts: Paola Bressan, Richard Brown, Patrick Cavanagh, David Eagleman, Marcos Pérez, the late Al Seckel, Adrienne Seiffert, George Mather, Suzanne McKee, Dale Purves, Arthur G. Shapiro, Dejan Todorović, Jonathan Winawer, Gideon Caplovitz, Max Dürsteler, Akiyoshi Kitaoka, Beau Lotto, Denis Pelli, Nava Rubin, Gianni Sarcone, Preeti Verghese, Michael Bach, Pietro Guardini, Frederick Kingdom, Margaret Livingstone, Peter Thompson, Niko Troje, Rob Jenkins, Rob van Lier, Eric Mead, Thomas Papathomas, Michael Pickard, Yuval Barkan, Maria Concetta Morrone, Richard Russell, Mark Seteducatti, Lothar Spillmann, Paul Doherty, Alan Gilchrist, Simone Gori, Jan Kremlacek, Xoana Troncoso, Anthony Barnhart, Po-Jang (Brown) Hsieh, Ming Meng, Mark Wexler, Jordan Suchow, Doris Tsao, Olivia Carter, Yuhong Jiang, Roger Newport, Victoria Skye, Christopher Tyler, Arash Afraz, Mahzarin Banaji, Jorge Otero-Millan, Michael Paradiso, Maria Victoria Sanchez-Vives, Thérèse Collins, Ava Do, Masashi Nakatani, Kimberly Orsten, Virginie van Wassenhove, and Qasim Zaidi.

Many sponsors have supported the contest over the years, with our thanks: The Mind Science Foundation and Scientific American have provided very generous and repeated support, as have SR Research, Arrington Research, Applied Science Laboratories, Crist Instruments, and SensoMotoric Instruments.

Dozens of volunteers contributed their time and effort to organizing the live contest, many of them for several years. In alphabetical order: Luis Alarcon-Martinez, Sarah Allred, Anthony Barnhart, Marian Berryhill, Marco Boi, Michael Campos, Gideon Caplovitz, James Christensen, Francisco Costela, Jie Cui, Tugba Demirci, Leandro Di Stasi, Simone Gori, Kai Hamburger, Tracey Herlihey, Steve Holloway, Michael Hout, Po-Jang (Brown) Hsieh, Yee Joon Kim, Peter Kohler, Kyle Mathewson, Michael McCamy, Simona Monaco, Ruben Moreno Bote, Ali Najafian Jazi, Jorge Otero-Millan, Nora Paymer, Martina Poletti, Carolyn Posey, Amrita Puri, Hector Rieiro, Alex Schlegel, Asya Shpiro, Aliya Solski, Debi Stranski, the late Alan Stubbs, Lore Thaler, Inna Tsirlin, Steve Walenchok, Tamara Watson, Danelle Wilbraham, Claudia Wilimzig, and Katharina Maria Zeiner. Xoana Troncoso, Jorge Otero-Millan, and Francisco Costela each served as chairs of the volunteer committee multiple times.

The contest's website has always been critical to sharing each year's finalist illusions with the wider community, and indispensable after the contest became a full online event in 2015. Jorge Otero-Millan designed the present website and maintained it for most of the contest's history. He also devised the present online voting system. Daniel Cortes-Rastrollo has helped maintain the contest's website since 2015 (a complex task, given the varied visual materials to be displayed!). Michael McCamy provided advance content to K–12 teachers for several years. We thank all the website visitors who have provided online donations to support the competition over the years.

The Vision Sciences Society also has our gratitude for kindly integrating the contest into their annual meeting for many years as an official satellite event. A special thank-you goes to former VSS presidents Marisa Carrasco

and Frans Verstraten, who worked hard to ensure a very successful and seamless collaboration between VSS and the contest, even letting us rent part of the VSS venue to hold the contest's tenth edition in 2014. Gideon Caplovitz and Arthur G. Shapiro made every effort to integrate the contest into the VSS program and coordinate it with the VSS Demo Night.

We have been incredibly fortunate to have the continued friendship and support of Mariette DiChristina, the editor in chief of *Scientific American*. Our relationship with the Scientific American family has been immensely rewarding over the years, which is one of the main reasons that we were so keen to move from our former home in Phoenix to New York City. In writing articles and blogs for *Scientific American, Scientific American Mind*, and the Scientific American website, we have worked with many wonderful editors, writers, and administrators. All of them have been uniformly outstanding, and helped make our writing so much better and clearer. Mariette herself, Daisy Yuhas, Kristin Ozelli, Claudia Wallis, Liz Tormes, Avonelle Wing, Ingrid Wickelgren, Ericka Skirpan, Kerrissa Lynch, Maya Harty, Andrea Gawrylewski, Christine Gorman, Fred Guterl, and Peter Brown worked with us on our articles for *Scientific American* and *Scientific American Mind*, as well as on three *Scientific American* special issues on illusions, published in 2010, 2013, and 2016. David Dobbs, Jonah Lehrer, and Gareth Cook served as editors of our online writings and subsequent column on the neuroscience of illusion, in the former Mind Matters section of ScientificAmerican.com. In 2013, our Mind Matters column gave rise to our present *Illusion Chasers* blog, edited first by Bora Zivkovic, then by Brainard Curtis, and presently by Michael Lemonick.

The idea for this book started with a number of feature articles that Mariette DiChristina commissioned for *Scientific American Mind* on the illusions submitted to the annual contest. It obviously made sense to compile and extend these writings into a full volume to be published under the Scientific American/Farrar, Straus and Giroux imprint. Our editors at FSG, Amanda Moon and Scott Borchert, guided us capably and knowledgeably through writing and revising. They are a true pleasure to work with.

We were privileged to have Jim Levine, of the Levine Greenberg Rostan literary agency, as our agent again, and to work again with his team, including Kerry Sparks and Elizabeth Fisher. All of them helped us with our previous book, *Sleights of Mind*, and we look forward to future projects together.

This book benefited greatly from the artwork of Robert Alexander, Jordi Chanovas Colomé, Daniel Cortes Rastrollo, Max Dorfman, Hector Rieiro, and Jorge Otero-Millan, who conceptualized and rendered many illustrations to help the reader visualize dynamic illusions in printed form. Jordi, Daniel, Max, and Rosario Malpica provided vital writing and administrative support for this project.

We are indebted to the funding organizations and individual sponsors that supported our laboratories' research programs and related academic endeavors and resulted in this book: the Barrow Neurological Foundation, the Mind Science Foundation, the National Science Foundation, the National Institutes of Health, the Department of Defense, the U.S. Army, Science Foundation Arizona, the Arizona Biomedical Research Commission, the Arizona Alzheimer's Consortium, the Dana Foundation, Procter & Gamble, Mrs. Grace Welton, Mrs. Marian Rochelle, the Empire Innovator Program, and Research to Prevent Blindness, Inc.

Finally, we thank our families. Steve's mother, Sarah Macknik, flies several times a year from Atlanta to New York to visit us and help us take care of our children, often while we are working on the contest. She has traveled with us to many countries, on three different continents. Our kids, Iago, Brais, and Nova, have participated in many informal perception experiments at home, and make it all worth it. They are, without doubt, our most successful and important collaboration, and the ongoing project that fills our hearts with the most joy.

ILLUSTRATION CREDITS

page 69 Petronas Twin Towers, used by permission of Thomas Haltner.
page 70 Checkered box, used by permission of Frederick A. A. Kingdom, Ali Yoonessi, and Elena Gheorgiu.
page 70 Manga girls, used by permission of Akiyoshi Kitaoka.
page 71 "A Turn in the Road," used by permission of Kimberley Orsten and James Pomerantz.
page 73 "Age Is All in Your Head," used by permission of Victoria Skye.
pages 74–75 "Through the Eyes of Giants," used by permission of Arash Afraz and Ken Nakayama.
page 76 "Stereo Vision Produces New Illusory Contours!" used by permission of Davi Geiger and Hiroshi Ishikawa.
page 77 "Hidden Strength of the Classical Simultaneous Contrast Illusion," image provided by Martinez-Conde and Macknik Laboratories.
page 78 "Nerve Impulse," courtesy of José Ferreira W.
page 81 "The Spinning Disks Illusion," used by permission of Johannes Zanker.
page 82 "The *Enigma* Illusion," both images used by permission of Jorge Otero-Millan.
page 85 "The Rotating-Tilted-Lines Illusion," used by permission of Simone Gori and Kai Hamburger.
page 86 "Pulsating Heart," courtesy of Gianni Sarcone, Courtney Smith, and Marie-Jo Waeber. Copyright © Gianni A. Sarcone, giannisarcone.com. All rights reserved.
page 87 "The Blurry Heart Illusion," used by permission of Kohske Takahashi, Ryosuke Niimi, and Katsumi Watanabe.
page 89 "The Rotating Snakes Illusion," used by permission of Akiyoshi Kitaoka.
page 90 "Snakes on a Brain," used by permission of Jorge Otero-Millan.
page 91 "Pinna Illusion," used by permission of Baingio Pinna.
page 93 "Floating Star," used by permission of Joseph Hautman, aka Kaia Nao. Copyright © Kaia Nao.
page 94 "Impossible Illusions," image provided by Martinez-Conde and Macknik Laboratories.
page 97 "Impossible Motion: Magnetic Slopes," courtesy of Kokichi Sugihara. Copyright © 2009 by Kokichi Sugihara.
page 99 "Elusive Arch," used by permission of Dejan Todorović.
page 101 "Impossible Illusory Triangle," used by permission of Christopher Tyler.
pages 102–103 *Three Bar Cube*, used by permission of Guido Moretti.
page 104 "Twisted Hands," used by permission of K. Brandon Barker and Claiborne Rice.
page 107 "The Disappearing Hand Trick," image provided by Robert Alexander.
page 109 "The Knobby Sphere Illusion," used by permission of Peter Tse.
page 111 "Fishbone Illusion," courtesy of Masashi Nakatani. Copyright © Masashi Nakatani.
page 114 Mac King performing onstage, used by permission of Mac King.
page 116 The Amaz!ng Randi and Dan Simons in a gorilla suit, used by permission of the estate of Alan Stubbs.
page 118 "The Monkey Business Illusion," figure provided by Daniel Simons, www.theinvisiblegorilla.com. From Simons, D. J., & Chabris, C. F. (1999). Gorillas in our midst: Sustained inattentional blindness for dynamic events. *Perception*, 28, 1059–1074.
page 121 "Attention to Brightness," used by permission of Peter Tse.
page 123 "Attention to Color," used by permission of Peter Tse.
page 125 "Attention to Afterimages," used by permission of Peter Tse.
page 126 "Expanding Flowers," used by permission of Akiyoshi Kitaoka.

Susana Martinez-Conde and Stephen Macknik are award-winning neuroscientists and professors at the State University of New York Downstate Medical Center. They are the authors of the international bestseller *Sleights of Mind: What the Neuroscience of Magic Reveals About Our Everyday Deceptions* and have written dozens of articles for publications such as *Scientific American*, *The New York Times*, *The Sunday Times* (London), and *How It Works*. Their *Scientific American* contributions include three special editions of *Scientific American: Mind* dedicated to their work. Their research has been covered by *The New York Times*, *The Wall Street Journal*, *Wired*, NPR, PBS's *NOVA*, and more. They produce the Best Illusion of the Year Contest. They live in Brooklyn. Visit their website at www.championsofillusionbook.com.